How to Paint
BUILDINGS

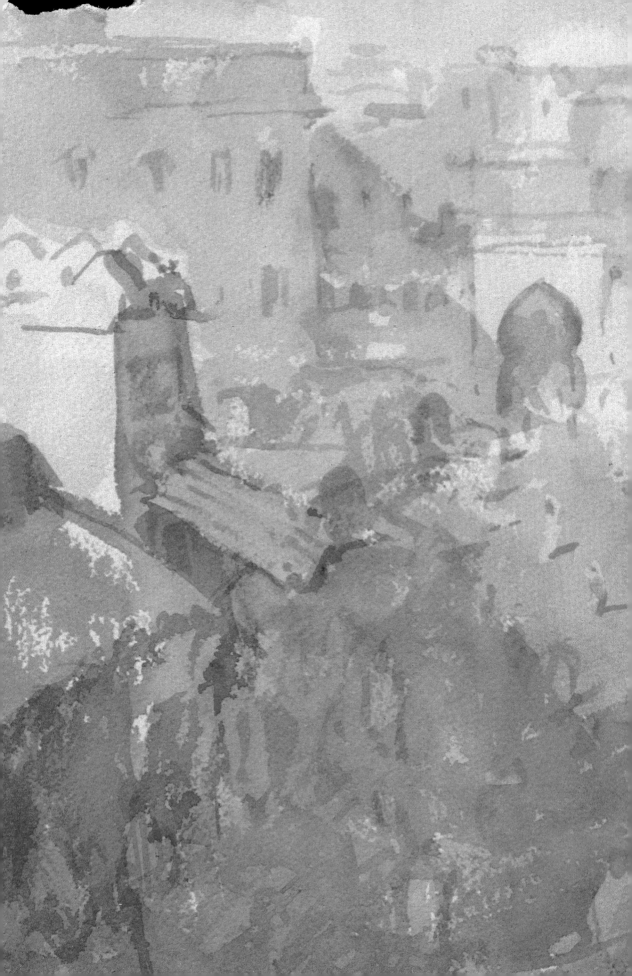

How to Paint
BUILDINGS

Muntsa Calbó Angrill
and Manel Plana Sicilia

Watson-Guptill Publications/New York

Copyright © 1991 by Parramón Ediciones, S.A.

First published in 1991 in the United States by Watson-Guptill
Publications, a division of BPI Communications, Inc.,
1515 Broadway, New York, NY 10036.

Library of Congress Cataloging-in-Publication Data

Calbó Angrill, Muntsa.
 [Cómo pintar el paisaje urbano a la acuarela. English]
 How to paint buildings / Muntsa Calbó Angrill and Manel Plana Sicilia.
 p. cm.—(Watson-Guptill artists library)
 Translation of: Cómo pintar el paisaje urbano a la acuarela.
 ISBN: 0-8230-2474-1
 1. Buildings in art. 2. Watercolor painting—Technique. I. Calbó
Angrill, Muntsa. II. Title. III. Series.
 ND2310.S513 1991
 751.42'244—dc20 90-49326
 CIP

Manufactured in Spain
Legal Deposit: B-1.922-91

1 2 3 4 5 6 7 8 9 / 95 94 93 92 91

Table of Contents

1

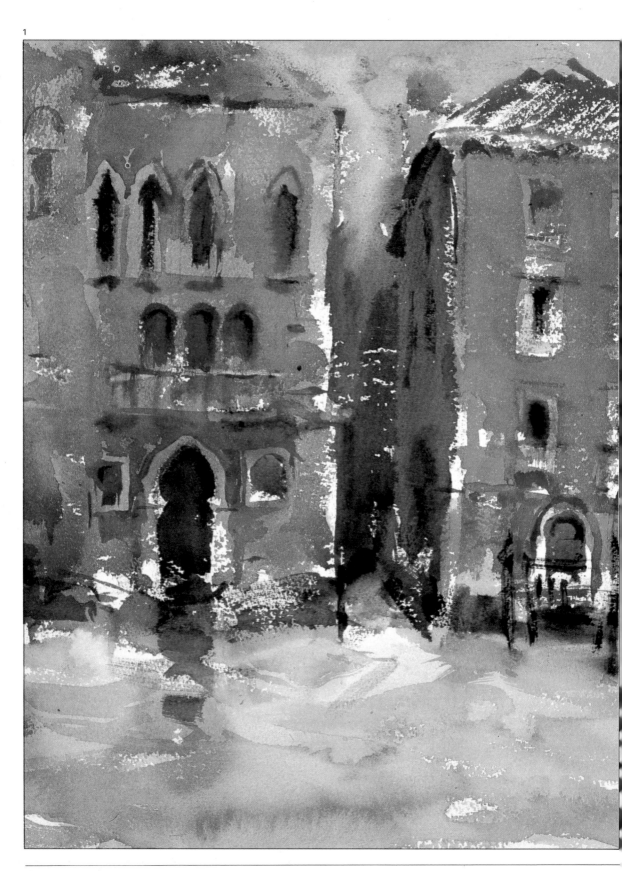

Introduction

I became acquainted with Manel Plana's work from the Catalan Watercolor Society; he had a watercolor that was being exhibited there. It was a still life watercolor, but because of the composition's painterly treatment, one thinks more about painting in general than about any specific theme.

Since that time, Plana has collaborated with me on a number of occasions. He participated in the creation of several books. Finally, as I was getting to know his work, his versatility coupled with an almost exclusive commitment to watercolor, I decided to publish a whole book about watercolor with his urban landscapes as the illustrations. Plana uses this theme continually, so I had a real problem: there were so many good paintings.

The urban landscape is a genre of painting that already has a long history. As we will see, it's a theme that changes with every period.

Also, Plana is a painter who is interested basically in inventing something new from an old theme; for this reason, Plana looks for variations in composition and graphic vocabulary as we will be discovering on these pages. Surely this is why he has won such important watercolor prizes as the National Watercolor Award in 1980.

Plana was born in 1949. He has always been involved with the creative, art field; he worked in advertising until he decided to paint exclusively. With advice from good painters, he learned to paint practically on his own, and even today,

twenty-one years later, he follows a rather independent path. He wants to find new interest in known themes, to make a good painting rather than to represent one scene or another.

Plana paints in watercolor. He knows his medium; he dominates it. He loves the fresh and free color on the white paper. He loves the light that emanates from the white areas and the light that becomes translucent from the colored water.

We hope to transmit to you from the pages of this book a little of this sentiment and of his understanding of watercolor applied especially to the urban landscape. We will explain in brief the theme's history since towns and cities were first painted in watercolor. We will suggest ways to select themes. And finally, Plana's paintings will serve as magnificent examples of theme, composition, illumination, color, and treatment.

For my part, I will try to make things accessible and above all, to awaken your sensibility and the desire to paint. I'll try to get you to paint those white pages with damp, brilliant, translucent colors. I never painted with watercolor before meeting Plana. But since I have seen him paint, since I have written this book, I use my brushes and my boxes of watercolor, trying to paint on any paper. Of course, I don't always get what I want. Watercolor is very free and very difficult, but a marvelous freshness exists in it. So—get ready!

Fig. 1. Manel Plana. *Venice*, (detail). The artist did this watercolor on a recent trip to Venice. It is a beautiful demonstration of how he controls the medium. Like all of Plana's work it is bright, sensitive to color, and full of lights and darks.

Fig. 2. Muntsa Calbó. *Self-Portrait*. The author of this book was born in 1963 and has her diploma in fine arts from the university in Barcelona.

Fig. 3. Manel Plana. *Self-Portrait*. Plana was born in 1949. He is a professional watercolorist who has won several important watercolor awards.

2 3

Watercolor as an artistic medium wasn't used much until well into the eighteenth century, but actually it is an ancient medium, probably having Egyptian origins. Oddly enough, the urban landscape didn't appear as a theme until the eighteenth century. And yet the coincidence is not surprising, because before that, everyday city life had never been developed enough to inspire artistic creation.

In this brief outline of the history of watercolor used for urban landscapes, you will be pleasantly surprised to find the works of some great painters. We will examine the themes, compositions, and pictorial treatments in these works as we proceed through the rest of the book.

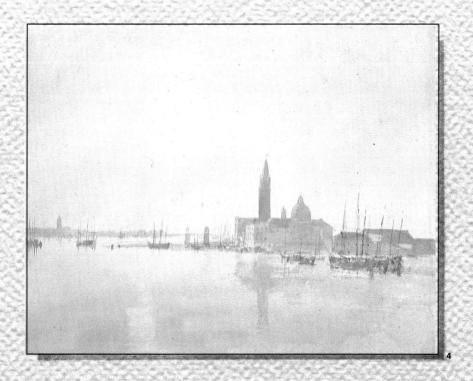

4

The history of urban landscape watercolor

The beginnings

5

Watercolor is an ancient medium. Egyptians used it to illustrate papyrus, but it took centuries for watercolor to become integrated into Western art. At first it appeared only in medieval miniatures. Then, in the Renaissance, only one artist painted many watercolors independently—works of art, not sketches—but what an artist: the best German painter of the sixteenth century and perhaps the best German painter of all time was Albrecht Dürer.

Dürer (1471–1528) was a living example of a Renaissance man: traveler, zealous reader, and writer of memoirs with profound ideas rooted in philosophical and spiritual thinking of his time. His thirst for knowledge led him to explore the visual world, to represent and document it, trusting completely in what he called man's noblest sense: vision.

Dürer's watercolors show a great attention to detail, a capacity for depicting the environment and the light that surrounds objects from a humble blade of grass to a rural landscape.

It is certain that Dürer painted some cities, but generally the urban landscape did not appear until the eighteenth century. Its direct predecessor is seventeenth-century Dutch painting, which "invented" the practice of landscape painting in general. Before, the urban scene appears only as a symbol rather than a subject in itself. (See fig. 5.)

Fig. 4. (Previous page.) Joseph Mallord William Turner. *St. George High Street from the Customs House*, Tate Gallery, London.

Fig. 5. Carlos de Orleans. *Poems, manuscript*, 1599, British Museum, London. Painters weren't only interested in reproducing daily life realistically. Cities that appeared as backgrounds in paintings were not necessarily actual cities; they were symbols.

Fig. 6. Albrecht Dürer. *The View of Kalchreuth*, Kuntshalle Bremen. This Renaissance painter was the first Westerner to paint an abundance of watercolors. This is one of them, a town rather than a city, a subject not very common in those days. Dürer controlled his brushstrokes and used color in a notably modern way, using a lot of whites.

6

The eighteenth century: The *vedutti*

The eighteenth century is sometimes called the Century of the Long Voyage since many wealthy and cultivated Europeans made trips to the cradles of civilization. The English were the most well traveled, and they went especially to Venice and to Rome. Tourists liked to bring home souvenirs, so Venetian artists produced pictures of the brilliant and luxurious canal city, and later, of Roman monuments. Definitely city scenes, these pictures were called *vedutti*, the Italian word for views. From this point on, the urban landscape became an independent genre. While many Venetians worked in this genre, two jump out at us—Francesco Guardi (1712–1793) and Canaletto (1697–1768).

Although they painted in oil, both also did monochromatic studies in gouache —a water-based medium—which they were also able to sell. Their drawings began to be reproduced in etchings and engravings. A development which was important in the appearance of the English watercolor.

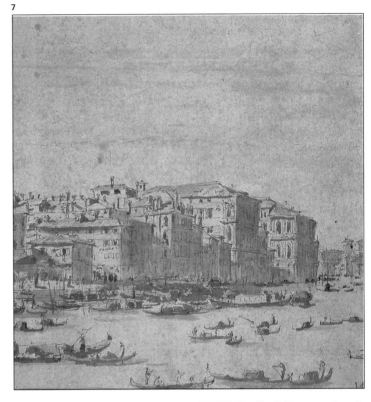

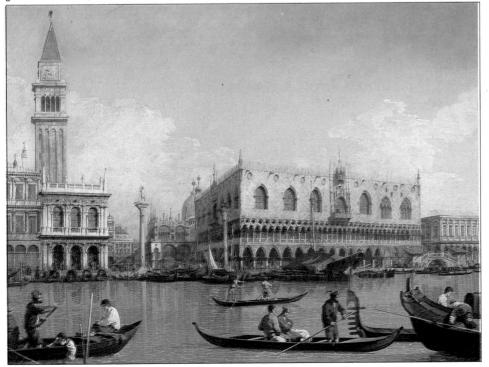

Fig. 7. Francesco Guardi. *Houses on the Grand Canal in Venice*, Albertina Museum, Vienna. Guardi, was possibly the best of the Italian *vedutti* painters. More than any other subject, he painted Venice, although he traveled to Rome and other cities. On occasion he used gouache as in this painting to study his theme.

Fig. 8. Canaletto. *St. Mark's Wharf*, Pinacoteca de Brera. Canaletto was one of the first painters interested in painting his city—not surprisingly, since Venice was a tourist attraction. But Canaletto and Guardi were not "commercial" painters; they were good painters who began the genre of urban landscape.

The watercolor in England: J. M. W. Turner

By the end of the eighteenth century, the English had developed a passion for engravings of distant places, and they began making them themselves. These engravings were not only of Italian landscapes, but also of their own country, a development that led to the renaissance of the watercolor in England.

Paul Sandby (1725–1809), began to "illuminate" these engravings with watercolor. Color steadily gained in importance until each engraving was worked as an original, becoming an authentic watercolor painting.

By the second half of the eighteenth century, the watercolor had become the English national art. The first group of watercolorists established the Royal Watercolorists Society. Most important among them was Joseph Mallord William Turner (1775–1851). Like Dürer, Turner was a Renaissance man. He began to paint watercolors in a workshop that an old doctor, called Munro, a

9

watercolor enthusiast, lent out to all artists who wanted to paint in this medium. Dr. Munro offered the painters dinner every day they worked in his studio.

Among others Turner knew Thomas Girtin, a young man his own age, who, had he not died at 27, might have dwarfed even Turner. That was Turner's opinion.

Of the two, however, Turner was the more imaginative. Girtin was content to represent the beauty that already existed; Turner was faithful to his own ideas, which he imposed upon reality.

Fig. 9. Joseph Mallord William Turner. *The Grand Canal at Dusk with the Little St. Simon*, British Library, London. J.M.W. Turner was the English painter who rediscovered and encouraged the use of watercolor. Never before had watercolor been treated so freely. Turner was among the first to take advantage of so many qualities intrinsic to the medium: creating an atmosphere, suggesting details, and the blending of tones.

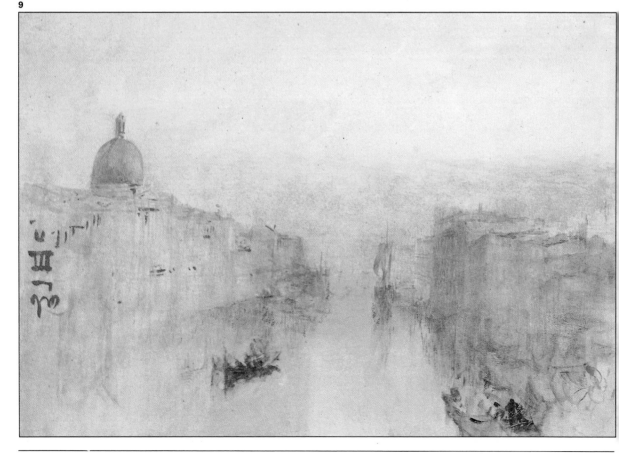

Turner belonged to the Royal Academy on the basis of his oil paintings. However, throughout his life he painted watercolors, experimenting with their expressive properties of color and light. Watercolor was the medium that permitted him to capture the atmosphere of light to produce suggestive, almost visionary, images.

He tried all the medium's possibilities: scratching, rubbing, absorbing, washing, touching up with tempera, ink, or pencil, superimposing, letting the paint drip spontaneously. At the same time he worked on landscapes in oil. He was an insatiable and restless traveler. He went all over Europe: Italy, France, Switzerland, Germany, and, of course, England.

In Italy, especially in Venice, Turner painted the city, seemingly bathed in water and light, pictures which are still a lesson for any watercolorist because they are brief, simple summaries of technical knowledge: They offer the impressive sensation of iridescent light, an almost brilliant clarity, and an abstract vision of color that transports the viewer to a place where the marvelous and the sublime reign. Turner is probably one of the two best British artists of all time together with his contemporary John Constable (1776–1837). Constable was completely different from Turner, but he also worked in watercolors to make studies of clouds and skies.

Fig. 10. Joseph Mallord William Turner. *The Grand Canal Looking Toward the Customs House*, British Museum, London. Thanks to Turner, the watercolor in England acquired artistic status. With Turner, we discover Venice's sensuality. This is a city that still attracts painters and blinds them with beauty. Venice prompted Western painters to focus on light-oriented urban themes.

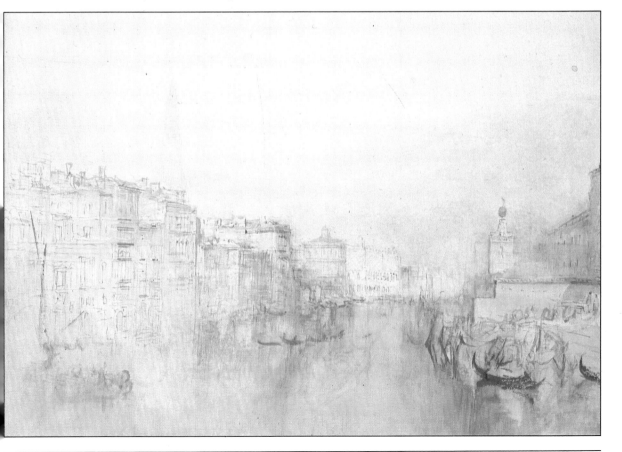

The watercolor in France: Delacroix

Watercolor became popular in England; it was independent of and at least as important as oil painting. But the same thing did not happen in the rest of Europe. In 1855, the English sent 114 watercolors to the Paris Universal Exhibition which very favorably surprised the French critics. No one had worked in this medium so thoroughly in France or produced such worthy results.

It was the British who propelled watercolor through Europe. Like Turner, many British painters chose urban and rural landscapes for their subjects. Their treatment was always picturesque. In foreign countries, they painted monuments, remote, hidden areas, old churches, and out-of-the-way towns, constructing a romantic vision of the landscape. Above all they valued the concept of the picturesque, meaning it was suitable for painting.

Richard Parkes Bonington (1801–1828) was one of the best British artists who traveled through France. He painted many watercolors during his journeys; watercolors that were published later in a sort of travel book. Bonington was a respected painter whose technique was perfect in its purity, and in its use of the medium's translucence. He could treat all manner of themes fluidly and with agility. He also had a sharp sense of color and used refined dull colors with touches of pure color, complementing and highlighting the color range.

When Bonington studied and worked in France, he introduced Eugène Delacroix (1798–1863) to the medium. They were both students of Gros, a well-known French painter of that time. Bonington's talent surprised the young Delacroix and inspired him to work in watercolor.

Figs. 11 and 12. Richard Parkes Bonington. *St. Armand Abbey*, private collection Rouen; and *The Leaning Towers, Bologne*, Wallace Collection, London. This English painter, above all a watercolorist, traveled through Europe (especially France), where he produced his best paintings. These two watercolors indicate that by this period the urban theme had become a genre and the English painters were the undisputed masters of the medium.

11

12

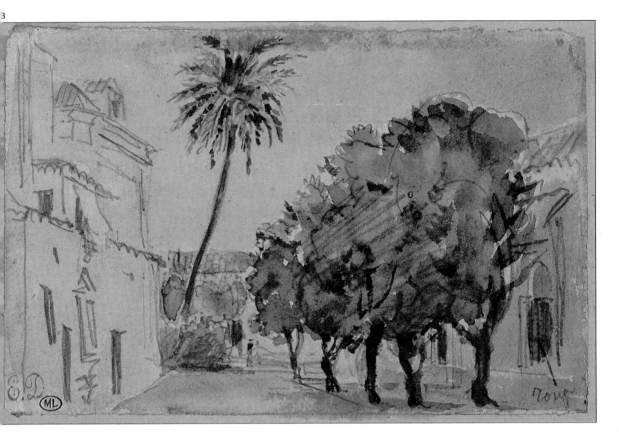

Fig. 13. Eugène Delacroix. *A Plaza in Seville,* Louvre, Paris. It is said that Delacroix learned to paint watercolor from Bonington. From the time the two men met, Delacroix used watercolor to make sketches on his trips, especially to southern Spain and Morocco.

In 1825, Delacroix traveled to England and met Bonington again. Bonington showed Delacroix the sketches he did in Morocco, awakening Delacroix's imagination, which at that time, was very romantic, colorful, and grand.

Delacroix took advantage of his stay in England to learn to paint watercolors, carefully observing Bonington's paintings, and those of Constable, which were in the museums. After this meeting, Delacroix painted in watercolors. His landscapes and sketches in this medium don't have the violent movement or the ferocious passion of his romantic scenes in oils. Instead they're refreshing, spontaneous, executed with quick, sure brushstrokes that show a profound knowledge of drawing.

He drew with a brush later, in the notebooks that he filled with sketches on his own trip to Morocco. On this trip, in 1832, he was dazzled by the light and color everywhere, filling notebook after notebook, just as Turner had done in Venice. The notebooks of the trip, with watercolor sketches of figures and landscapes and with little written texts and all types of notes, are in themselves truly works of art.

The Impressionists

Since its appearance at the end of the nineteenth century, Impressionism has become a classic style. In other words, a style we understand, a form of painting that seems "logical" and "natural." But the people of the nineteenth century lived in a world very different from ours; enormous social and economic changes were taking place; the rise of industry and progress in science and engineering led to great technological advances.

Nevertheless, art was still immersed in traditional representation of the human figure, historical themes, and picturesque landscapes. The question of picturesqueness is especially relevant to our discussion of the urban landscape. Because they painted only what was considered "suitable," in the traditional style, urban landscape painters were limited to repeating what was already hanging in museums. They could do nothing new. But a revolution in painting followed the social and economic revolution. Attitudes changed.

Before Impressionism appeared there was a realist phase which paved the way for the change to come. The realists' idea was to represent reality as they saw it, not as it ought to be or as they imagined it. Then Monet and his Impressionist friends changed everything, focusing painting's interest not so much in theme as in technique. They began to paint outdoors, letting themselves be carried away by changing impressions of what they saw. Impressionists painted directly, without previous preparation, study, or record of the real way light fades in an object's contours, variations in colors, and vibrations in the atmosphere. Like the Dutch bourgeoisie of the seventeenth century, they bypassed highbrow and picturesque themes, preferring ordinary subjects from everyday life and real settings.

14

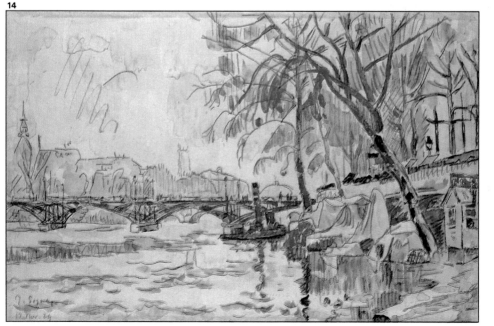

Fig. 14. Paul Signac. *View of the Seine in Paris*, Hamburg Kunstshalle. Signac was a Post-impressionist. He studied the breakdown of colors with Seurat, the Pointillist. And like Seurat, he used tiny points of pure color, which the viewer's eye joined visually. This method allows the grays, browns, greens, and shadows to appear even though the painter hasn't put them in. Signac found in watercolor a medium that permitted him to paint with pure translucent colors supported by a strong drawing as in this urban landscape.

15

Fig. 15. James Abbot McNeil Whistler. *The Children of Chelsea,* Freer Gallery of Art, Smithsonian Institution Washington, D.C. Whistler was an English painter who often worked in France. Whistler was enthusiastic about capturing the grayish atmosphere of evenings in watercolor.

Even though it seems difficult for us to understand the extent of the change the Impressionists made, we know that it was comprehensive in two ways: the subject matter of the painting, and the techniques.

At first the changes weren't welcomed. As far as themes went, people were offended and disgusted when they visited the first exhibits: train stations, suburban streets, workers, markets, popular dances, and busy streets were not by any means picturesque themes.

Nor did audiences approve of painting outdoors, using atypical points of view. They were used to artists breaking up compositions by cutting off basic elements and putting obstacles in the foreground, or getting carried away with pure color—color mixed only in the observer's mind and eye.

Even though they broke with tradition, Impressionists learned from it: A latent Impressionism vibrated in the works of Velázquez, Goya, Turner, and Delacroix. Next came the Postimpressionists, who created many styles thanks to the Impressionists. Some North American painters who were contemporaries of the Impressionists added to this succeeding pictorial revolution. Three of the most important, James McNeill Whistler, Mary Cassatt, and John Singer Sargent,

traveled to Europe, were authentic Impressionists (and magnificent watercolorists). Among the European Postimpressionists was Paul Signac (1863–1935), who was Georges Seurat's disciple. He used watercolor in his urban landscapes. And Paul Cézanne (1839–1906) who painted hundreds of watercolors, taking maximum advantage of the medium's color transparency, allowing him to consider the paper as a possibility for expression.

Fig. 16. Maurice Utrillo. *St. Rustic Street Covered with Snow,* Paul Petrides Collection, Paris. Although watercolor wasn't the medium preferred by the Impressionists, the urban landscape was a theme they loved. This watercolor, one of the few that Utrillo painted, has a touch of white gouache. It shows Utrillo's somewhat naive, childish style.

16

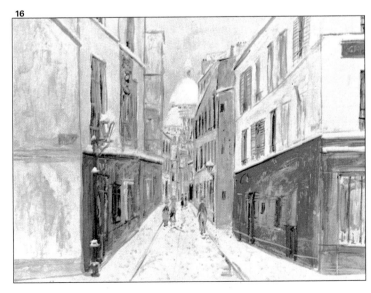

The twentienth century. Expressionism and the avant-garde

Cézanne is the key to understanding twentieth-century art. On one hand, he had profound conviction in imposing his own ideas, his personal vision on his model, and on the other hand, he had an enormous capacity for repeating a theme in dozens of studies, in order to achieve his main pictorial objective.

At least 600 watercolors by Cézanne have been kept, and these are paintings which, for the most part, have shown him to be a genius.

Through his watercolors he achieved a constructive lyricism, reaching the equilibrium that he so desired at the end of his life. He superimposed transparent colors into flat layers that build up the object. Colors were united with the white of the paper, to represent light and generate the theme's basic structure.

Cézanne hardly painted any urban landscapes, maybe because he lived in the country. But his work is relevant because the Cubist painters learned their lessons from him. By way of Cubism, the first abstract watercolor was painted by Wassily Kandinsky.

In fact, the great vanguard painters of the beginning of the century did not paint many watercolors.

Henry Matisse (1869–1954) was able to create a gentle, superbly decorative painting in which he connected his innate sense of color with a perfect composition. Matisse was the leader of the Fauves. Remember that Fauvism involved working from color as a basis to using it to create a new reality. Matisse painted in watercolor occasionally.

Fig. 17. Lyonel Feininger. *Treptovw Stree over the River Rega* Staatliche Graphishe Sammlung. Feininger, an American who moved to Germany, participated in important artistic movements at the beginning of the century. He was one of the professors at the Bauhaus, the famous German art school tha disappeared when the Nazis came into power At the Bauhaus, a great deal of importance was placed on the relation ship between the arts, the crafts, and architecture. In Feininger's work we often see urban landscapes, always with a geometrical drawing. In his watercolors he used washes to pervade the space. His harmonies are always tans, blues, and dull colors.

17

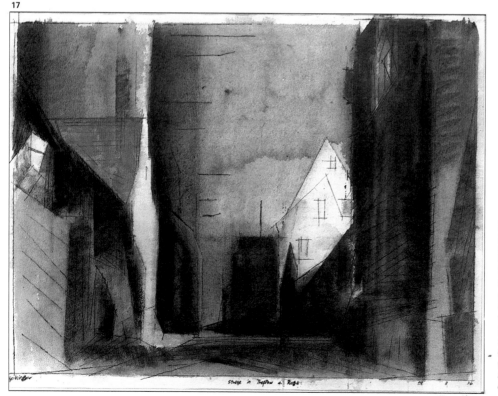

Fig. 18 opposite. Henri Matisse. *Notre Dame*, private collection. Matisse is one of the most important painters of the twentieth century, but he painted little in watercolor. Nevertheless, when he did, as in this painting, he achieved the same excellence as he did with oils: an exquisite richness of nuances and a continuous cultivation of contrast and harmony.

Paul Klee (1879–1940) often painted in watercolor, following Cézanne's chromaticism, using a Cubist syntax and a very personal lyricism. In a sense Klee created a new watercolor language, always vibrant with color. He produced fresh, very poetic watercolors, always focusing more on the painting than the theme, using abstraction to express ideas. Klee tried various types of canvas and treatments. He painted several watercolors in which the *only* thing that mattered was color, which he considered "the irrational painting element."

Lyonel Feininger (1871–1956), a North American who went to live in Germany, where he knew Klee and gave classes with him in the Bauhaus school, used watercolor to represent subtle, poetic visions. Although his paintings always dealt with a particular theme—houses, ports, sea, boats—what mattered to Feininger was the building up of layers of color. These colors were made up of elegant and balanced harmonies, the artist's interior expression.

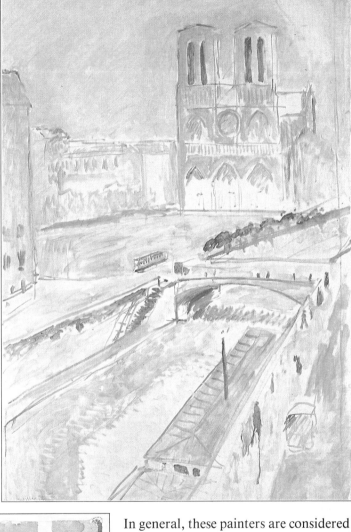

Fig. 19. Paul Klee. *St. Germain after Tunisia*, Georges Pompidou Center, Paris. Like Feininger, Klee was a Bauhaus professor, and he was also one of the most imaginative, independent, poetic, and decorative painters of our century. After his trip to Tunisia, color figured explosively in his work, as in this watercolor.

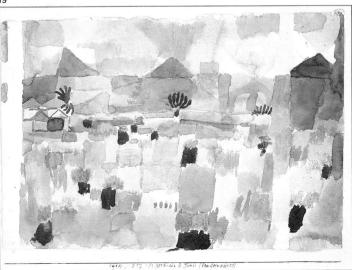

In general, these painters are considered Expressionists. Keep in mind that, although one thinks of Expressionism as a violent representation of passion—instinct valued above reason, the undoing of color and exaggeration in drawing—in reality, Expressionism springs from the artist's conviction that art serves the purpose of expressing one's interior vision. The styles that Cézanne, Vincent van Gogh (1853–1890), and Paul Gauguin (1848–1903) initiated at the end of the nineteenth century, subordinated absolute reality to paint what was important.

North Americans in the nineteenth and twentieth centuries

The majority of North American artists who studied painting in the nineteenth and early twentieth centuries went to Paris. At first this meant they painted no watercolors, since the medium wasn't well respected in France. But at the end of the nineteenth century a group of artists exploring Expressionist painting discovered watercolor.

Winslow Homer (1836–1910) was the best of these American pioneers. He used rich colors and loose brushstrokes to capture everything possible in nature—the sea and the wind, fishing, the trees, and the humid tropical beaches.

John Singer Sargent (1856–1925) was a true virtuoso who found in watercolor an ideal way of painting for no one other than himself, since his oil paintings were always commissioned. He interpreted simple improvised themes with brilliant abstract stains that surpassed those of Impressionism. Sargent gave the American watercolor its triumphant breakthrough.

Maurice Prendergast (1859–1924) traveled to Paris and to Venice, like Sargent.

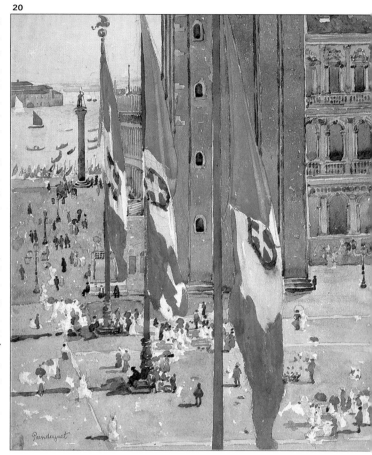

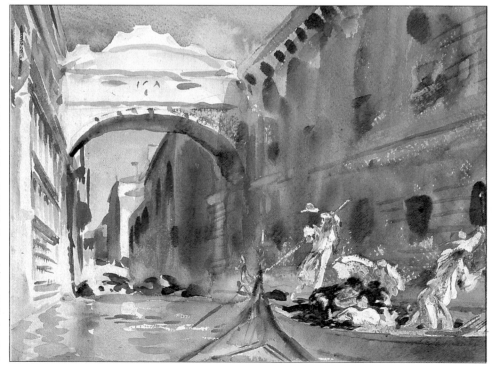

Fig. 20. Maurice Prendergast. *St. Mark's Place*, Metropolitan Museum of Art, New York. As a North American who traveled to Europe and became an Impressionist, Prendergast was attracted to urban places filled with people. Here is a magnificent view of the Plaza San Marco in Venice.

Fig. 21. John Singer Sargent. *The Bridge of Sighs*, Brooklyn Museum, New York. Sargent painted many watercolors for his own pleasure. Some think these paintings turned out to be even better than his oils.

22

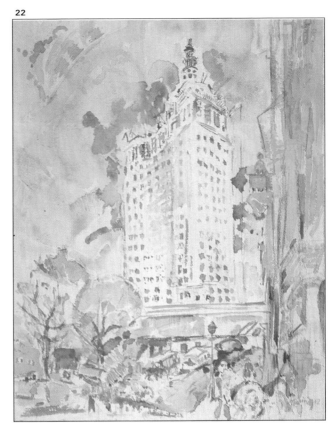

He was impressed by the paintings of Paul Bonnard, Signac, and Cézanne, and he absorbed their influence without losing his personality, creating little masterpieces out of simple scenes, such as people climbing stairs.

John Marin (1870–1953) as well as Edward Hopper (1882–1967) belong to the next generation. Both painted modern urban landscapes, in which the force of a big city is powerfully expressed. Marin focused on movement and bustle; Hopper, on loneliness and anonymity.

Although Hopper was not commercially successful in his lifetime, he is now widely recognized as a master. His Impressionist style, which seems realistic at first glance, is characterized by an unblinking honesty that seems almost unhuman.

23

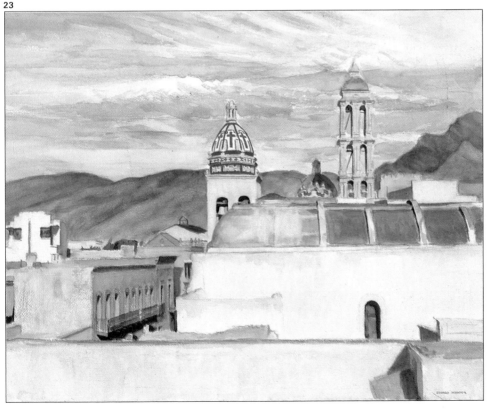

Fig. 22. John Marin. *Municipal Building, New York*, Philadelphia Museum of Art. In this watercolor with an urban theme, Marin prominently leaves out the whites. Notice the rapid brushstrokes, sufficient for describing the foreground and background, and the way he resolves a crowd of people, cars, and trees in the street.

Fig. 23. Edward Hopper. *St. Stephen's Church*, Metropolitan Museum of Art, New York. This work is very modern, very honest. There is a hard, cold reality to it.

The present

Many contemporary painters work in watercolor, almost always doing delicate, figurative work. For some, urban landscapes are just another theme. But others, like North American David Levine (Fig. 24) use the theme exclusively. Levine (b. 1926) is a brilliant watercolorist, who paints mostly New York urban landscapes especially noteworthy for their incorporation of the past, the wear and tear caused by time.

Ives Brayer always paints in watercolor, drawing short lines with lead pencil first to construct his theme. He always works outdoors, synthesizing form and color without detail, taking advantage of the medium's luminosity.

The pictures on these pages help to reveal the modern commitment to watercolor; the painters are contemporary, and they come from a variety of backgrounds.

Throughout this book, we will be accompanied by Manel Plana, a young watercolorist whom we will get to know and from whom we will learn. He not only knows the medium, but he is inspiring in his treatment of the urban landscape theme as well.

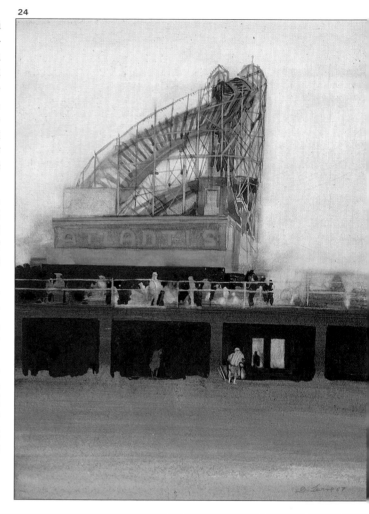

24

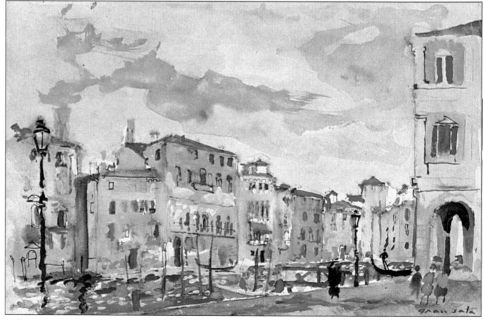

25

Fig. 24. David Levine. *Atlantis*, Brooklyn Museum, New York. Since Sar Sargent, a number of North Americans have become respected watercolorists. Levine is one of them. His preferred theme is the very worn urban landscape: rundown neighborhoods, rusty amusement parks, and so on.

Fig. 25. Emili Grau Sala. *Venice*, private collection. Grau Sala rarely paints in watercolor, but here is his treatment of the classic theme of Venice.

Fig. 26. Yves Brayer *Venice*, private collection. Another treatment of Venice in watercolor, by Brayer, who is primarily a watercolorist. His technique is exact and direct; he reserves a great deal of white, and he is supported by a strong drawing.

Fig. 27. Martinez Lozano. *Balinese Dances*, private collection, Barcelona.

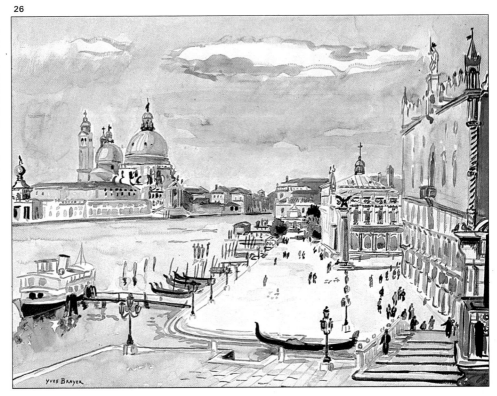

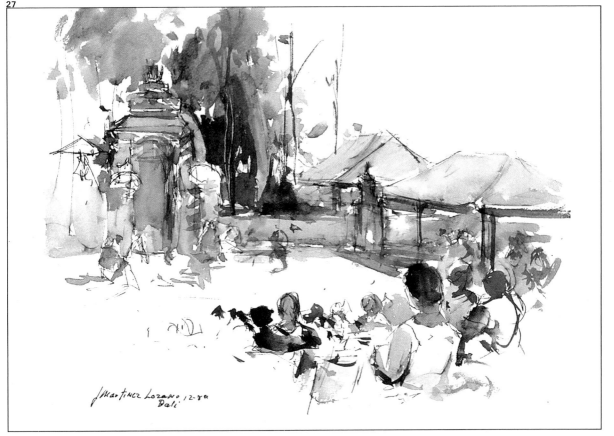

In order to paint in any medium, you need a canvas or a support, colors, a dilutant, and tools to put the colors on the support. In watercolor, the support is paper, the colors come in tubes or pans, the dilutant is water, and the tools are brushes. Other materials are sometimes necessary as well. We're going to talk about all that very briefly, and we will see the materials Manel Plana uses, since a painter's experience always provides the best guidelines.
At the end of this book, you can see and read how Plana paints watercolors.

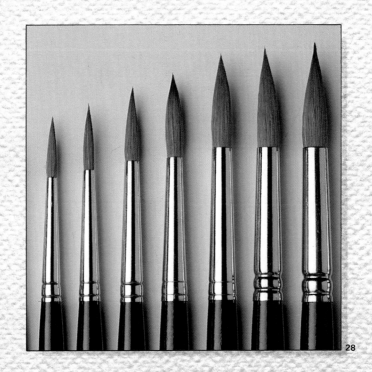

28

Materials and tools

In general

An easel is not absolutely necessary for painting in watercolor; a folder or a plywood drawing board will do (a). The support is paper (b). You need no turpentine, only water (c), a natural sponge (d), a rag or a roll of paper towels (e), and clips (or thumbtacks) to hold the paper on the board (f). You will need a palette and brushes. Only two are essential: a number 12 or 14 round sable hair (h) and a wide polecat or synthetic paintbrush (i). Of course, with a wider selection of brushes, you'll have an easier time. These additional brushes are: a wide Japanese deer-hair brush (j), a number 8 sable-hair brush (k), and a brush with a beveled handle for opening whites (1).

You will also need a HB pencil (m), a rubber eraser (n), a pencil sharpener (o), and two special tools to cover areas to be reserved or left out: drawing gum (p) or a wax rubbing stick (q). The drawing gum is applied with an old or used brush to areas that you want to leave out. You let it dry and then paint over it. Later you take it off with a rubber eraser. You can get the same results with white wax. The colors can be liquid (r), like those used by illustrators and for painting in airbrush; cake colors in pans (s) which come in metal boxes that also serve as palettes (t). Speaking of palettes and empty spaces, remember that you can use plastic boxes of color, too. Watercolors with a creamy texture come in tubes (u), and a palette like this one (g) should be used with them.

If you are painting in the studio, use a water container with a wide mouth; for painting outdoors, a narrow-necked plastic container is recommended, and so is a bottle for clean water.

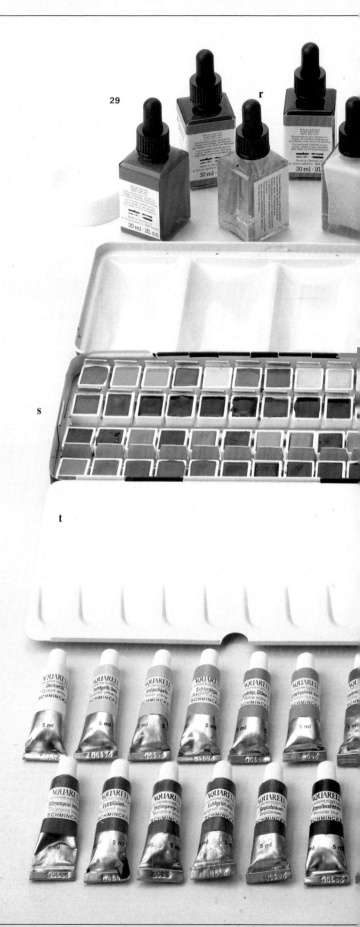

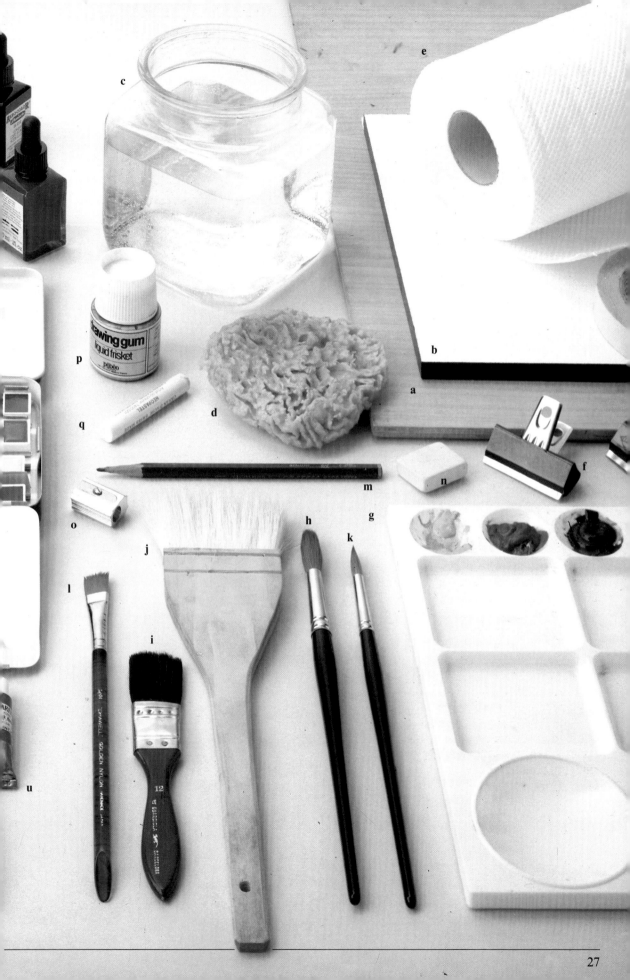

c

e

p

drawing gum
liquid frisket
pébéo

q

d

b

a

f

m

n

o

g

h

j

k

l

i

u

27

Manel Plana's papers, brushes, and colors

Any good watercolorist doesn't need many brushes or materials to make a good picture; this is the case with Plana. The watercolors in this book, the watercolors that Plana will paint in front of us, have been done with just the brushes (fig. 31) and colors (fig. 32) you see here.

As for paper, Plana usually uses thick- or medium-grain Whatman paper (fig. 30, the paper at the bottom of the pile) for his large- or medium-size paintings.

For his little sketches, he uses all qualities and brands (Fabriano, Canson, Guarro, Shoeller. . .) and grains. He also uses paper that is considered useless for watercolors: recycled (too absorbent), Ingres or Canson drawing paper, or satiny papers. Sometimes he gets surprising results by taking advantage of the paper's difficulty and defects.

Plana paints with the following colors (fig. 32): medium yellow (1), cadmium yellow dark (2) or orange, permanent red (3), raw sienna (4), sepia (5), Van Dyck red or sienna (6), cobalt blue (7) or light ultramarine blue, alizarin crimson (8), and indigo (9) or black ivory. Nine or ten colors are sufficient for creating the delectable ranges that you are going to see.

Plana uses only fives brushes:
A. A very thick French *putois* polecat-hair brush. He uses it for everything!
B. A large wide brush for big areas.
C., D. Flat cat's-tongue ox-hair brushes, one very wide and another medium.
E. A very worn narrow horsehair brush. This is an oil paintbrush, but Plana uses it for drawing with watercolor and for rubbing color on paper—in both cases, because it can't be loaded and won't retain much water.
When he can, Plana paints with a large palette using a big bottle of tap water—really a plastic bucket. He uses a sponge to clean the palette. He usually holds the paper in place with thumbtacks or clips but never uses tape.

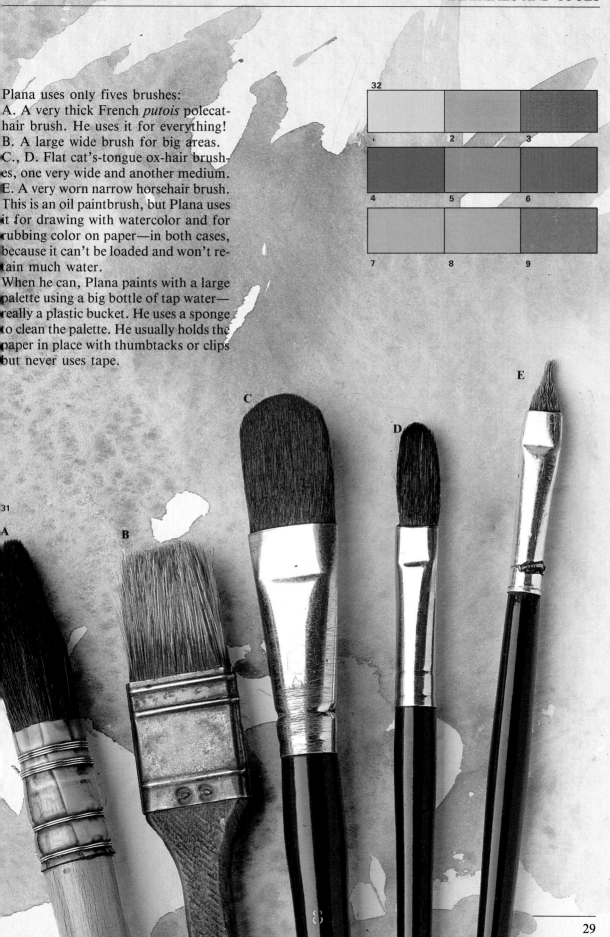

Indoors and outdoors

33

Fig. 33. Plana prefers painting outdoors. When he paints from sketches at home, he always says "things are missing." Nevertheless, two rooms in his house are his studios, one set up as a gallery and another as a storage area. Plana has filled the walls with paintings from twenty years of work. Paintings are everywhere.

Fig. 34. Plana loves being in nature. He enjoys the weather problems and changing light. He carries a paint-box easel, a folding drawing board, a large brush, a bottle for carrying water, and a bucket. His hat protects his eyes from the sun or his head from the cold. He carries everything in a basket. And since his paintings are usually large, he carries his paper rolled up.

34

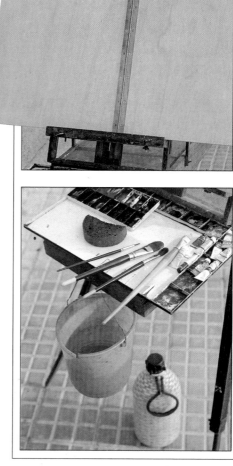

The problem with drawing is
that you have to represent masses
and objects in space on a flat
surface. The solutions are
innumerable.
Because our perception is, above
all, empirical and conventional...
this conventional reflection of the
exterior world that drawing
provides us with is incomparably
more determined than the dry
process of photography. The lens
captures "useless" lights and
shadows. The painter's eye lends
a human touch to the objects and
reproduces things as the human
eye sees them.

—Pierre Bonnard

The drawing

The necessity of drawing

Repeatedly, in the conversations we have had during the writing of this book, Manel Plana has spoken about the necessity of drawing. He was referring specifically to his recent paintings with a Venetian theme. He means that, when it comes to painting urban landscapes in whatever medium, one must be very specific about the different styles of architecture that comprise different scenes. Or, to put it another way: The correct drawing of the subject is what distinguishes one theme from another.

Of course this isn't our only consideration: We are talking about painting in watercolor, and watercolor is a medium that immediately and quickly resolves a painting. There can't be many corrections since you can't hide, erase, or fix mistakes easily.

So it should be obvious that in order to paint urban landscapes in watercolor, one must study drawing. You must prepare the mind for measuring, get the proportions right, and have a loose hand that is ready to respond without problems when you are painting.

Now, since we are going to speak about drawing, about basic ideas that will serve as a point of reference, we can seriously begin to discuss the subject.

We can begin by saying that it is necessary to draw often and continuously. You must exercise the powers of observation always, as John Singer Sargent advised his students. The drawing can take many various forms, and none of them have to be perfect.

For me, drawing is establishing and describing the order of the subject that I am trying to represent, with a minimum amount of resources (for example, a piece of paper and color).

What do I mean by order?

To explain, let's start at the beginning. Our subject, in this case—urban landscape— has as many aspects to it as life itself does; I can say that the thousands of sensations that are presented to me for observation are so overwhelming that in the actual painting it is impossible to convey them all. This is why I bring up the question of order.

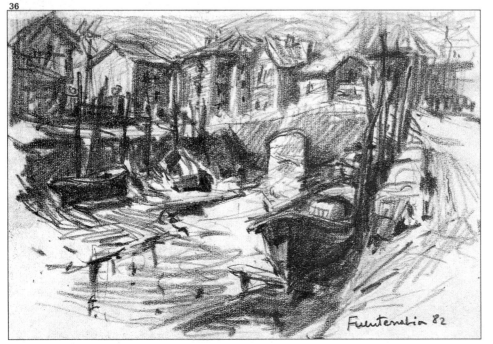

36

Fig. 36. Manel Plana. *Fuenterrabia*. This drawing was done with a fat pencil. Depending on the theme, Plana either draws in charcoal, with a fat pencil, or with pastel. This drawing is the same size of the watercolor he will paint later. By drawing, he forces himself to select among the various interesting facets of the subject. For example, the color and the line are what draws his attention. After doing two or three drawings, Plana can attack his watercolor with more security, and watercolor is a medium that demands security.

Plana, like everyone else, is interested in that one characteristic which is going to define a subject. In other words, we are going to "order" our receptivity. Ordering, in this case, is equivalent to choosing, comparing, classifying. Questions that will permit us to establish this order, this drawing, are varied. Some arise when one learns how to draw: the framework, proportions, illumination, contrast, perspective. And although all of these considerations are useful for drawing, it's good to keep in mind that each theme affects us in some particular way. There are themes whose perspective is very marked (see fig. 37); themes that are characterized by contrast and illumination (see fig. 38); themes in which the most important characteristics should be measured correctly and emphasized (see fig. 39).

Speaking of framing the composition and lighting it, as well as its perspective, we must remind ourselves from this moment on that we must always compare the different parts of the subject. We must compare, in each case, dimensions, lighting, lines, and so on.

Finally, each artist develops a preference for one theme or another. For example, Plana openly admits that he is attracted by themes that have strong contrasts of light and dark (see fig. 36).

In this chapter we are going to briefly study three important factors: framing, lighting, and perspective. You must learn and use them at the same time, although one aspect will always predominate, depending upon the theme.

Fig. 37. Muntsa Calbó. *A Street in Bath*. I drew this sketch to show that some themes demand a knowledge of perspective. The parallel lines disappear toward the same point to convey distance.

Fig. 38. Muntsa Calbó. *By the Thames*. Such themes demand that you keep in mind the different illuminations.

Fig. 39. Muntsa Calbó. *Durro*. I constructed the sketch by measuring and comparing all the dimensions of the houses.

38

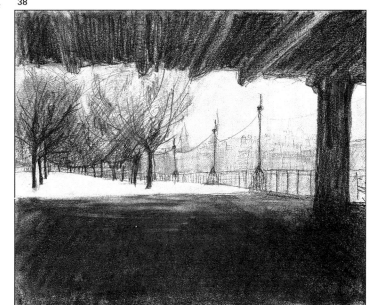

37

39

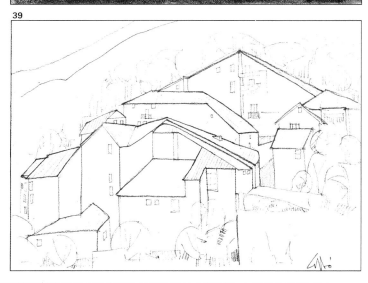

Fitting things in

40

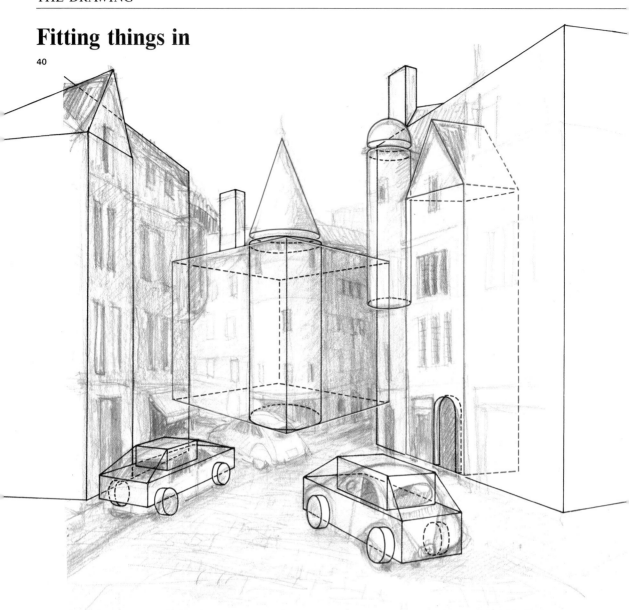

To draw is to express an idea, to describe an arrangement, to choose what is important. Very well, but how?

The question of how—what it means to confront the problem of a drawing and resolve it with a minimum of repetition and maximum clarity, with well-defined structure, is what we're going to deal with now.

The urban landscape is a theme which at first presents some particular difficulties apart from the pictorial problems found in any theme. The composition, lighting, color, rhythms, and various problems of the urban view (the effects of depth, the atmosphere and environment, and the effects of size) must all be solved on paper.

We start by framing the large quantities, remembering Cézanne's words: "In nature everything is modeled after three basic shapes: the cube, the cylinder, and the sphere. It's necessary to learn how to draw these simple shapes and then to be able to do what you want with them." You, who are learning to paint, perhaps you already know—although we can never know too much—surely, you know these words of Cézanne. Very well. They apply to urban landscapes as well as to nature, since buildings are normally great cubes or rectangular prisms, sometimes cylinders or cones, and sometimes pyramids or half spheres.

Fig. 40. I sketched th street in Edinburgh an later I "boxed" the bas forms that underlay th objects. In black are th basic cubes, the thre blocks; in red are th secondary shapes, w thin and on the bas shapes. When you draw an urban landscape, be gin by boxing. This is basic exercise in drawin to avoid getting lost i details, which can be ad ded later.

Proportions

Fig. 41. We are going to figure out how to draw this building. This is a basic drawing problem: achieving a coherent size and shape. Don't forget to measure by eye, approximating and comparing.

Fig. 42. We note that each of the towers is about one third as wide as the total width of the front of the building. We call the width of each tower "a," and we'll also call the distance between the towers "a."

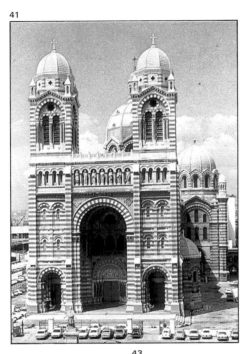

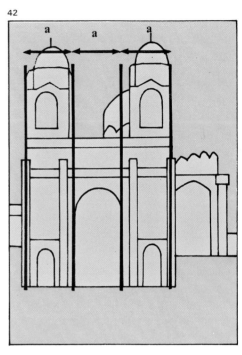

"Exercise the first look and learn how to calculate the true length and width of objects."

Leonardo da Vinci

Da Vinci wrote many words of advice like this in his *Treatise on Painting*, advice that is still valid today, after five centuries. It is still the job of the painter to establish his subject's dimensions by eye. In what way? Again, as we have indicated, in this case, it is a question of comparing elements and relating their measurements, putting things in proportion.

We set up the basic lines that structure the theme; these lines form a kind of weave wherein we can introduce a secondary shape. To do this, we use two systems at once: mental calculations and real calculations of dimension and proportion.

The mental calculations deal with comparing and relating the dimensions of visible elements. We ask ourselves dozens of questions that interrelate the measurements of the elements involved. This type of calculation complements the actual physical calculations required for the transference of the ideas onto paper

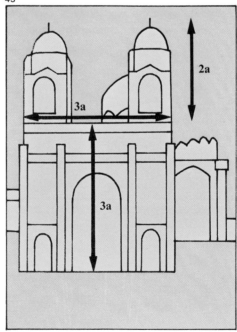

Fig. 43. Let's compare other measurements. We'll notice that the width "3a," is approximately equal to the height of the building without the towers. We indicate this height with "3a." We can deduce the height of each of the towers by comparing it to the heights we already know. It is twice the width of a tower, in other words, "2a."

with lines and paint. This means you must establish a measurement on paper, and everything else in the picture must relate to this measurement. If in reality a tower is twice as tall as a house, for example, it must be twice the height on paper, although the measurements are smaller.

The third dimension

The importance of the effect of depth in an urban landscape comes as a given, because the elements are positioned in a three-dimensional space. This reality, which seems to us obvious and natural, has to be represented on a two-dimensional space. Paper has only length and width.

It's a problem that has various solutions, which can be applied separately or together:

• Superimposing of levels
• Perspective
• Atmosphere and contrast

Superimposition deals with the representation of elements on distinct levels (foreground, middle ground, background), what painters sometimes call depth. In other words, a drawing that gives the impression that the elements are one behind the other; they are superimposed over others. To put it more simply, the elements overlap. The viewer is thus made to believe that some elements are closer and others are further away. The Impressionists often used superimposition, they even carried it to the extreme, placing something large in the foreground—a

visual obstacle that immediately suggests the depth (a tree, a post, a person, a window frame...) and implies relative sizes of various objects as well.

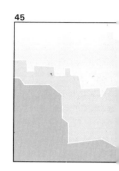

45

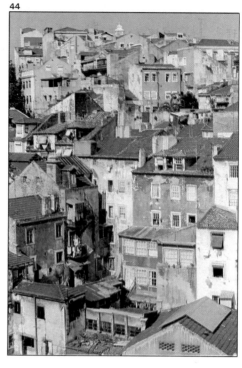

44

Figs. 44 and 45. To paint an urban landscape like this Lisbon neighborhood, we would superimpose levels of buildings. This is what we summarize in figure 45.

Fig. 46. Manel Plana *Venice*. In this painting Plana superimposed levels to convey depth. The gondola covers part of the background. Since it is bigger, we realize it is nearer to us than the houses half-covered by the gondolas.

Figs. 47 and 48. The painter places himself at a certain distance from the theme of an urban landscape. Let's imagine the painter's eye sending out lines to each of the building's points. Imagine that the paper is like a window in front of him. If what he saw were recorded on the plane of the paper window, the foreshortening of perspective would be the result.

46

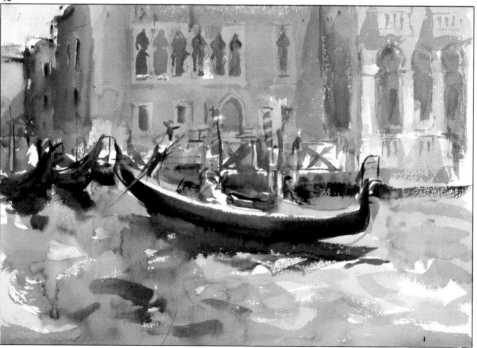

Perspective

The conic perspective reproduces our sense of space on a flat surface (paper or canvas). *It is the representation (of three-dimensional objects) on a two-dimensional surface.*

When depicting buildings, the painter must have a basic knowledge of the laws of perspective. First we will talk about the essential points. Please read the captions accompanying figures 47 and 48, on this page.

Horizon (H) This is the line that is always found in front of you at eye level.

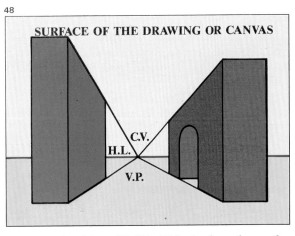

48

SURFACE OF THE DRAWING OR CANVAS

Center of Vision (C.V.) This is found on the horizon line in the center of the viewer's line of vision. It is also called the point of view (P.V.).

Vanishing Points (V.P.) Vanishing points located on the horizon, indicate the distant points at which lines seem to converge. Vanishing points create the illusion of depth in the painting.

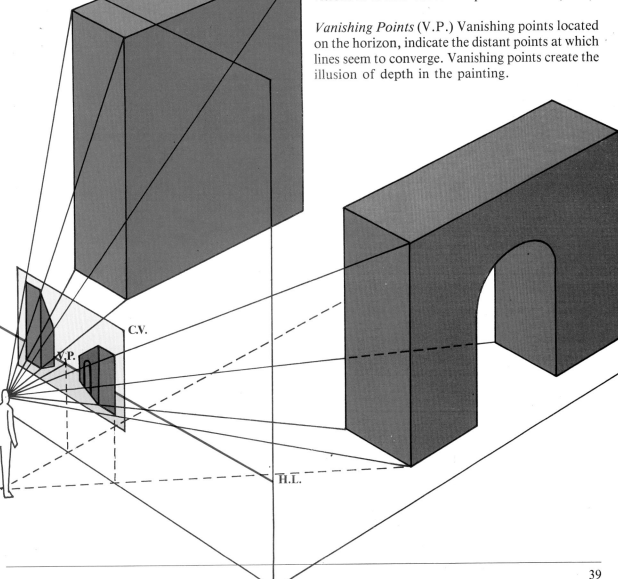

47

Parallel Perspective

This type of perspective, with only one vanishing point located on the horizon, is certainly the simplest to represent and understand. Furthermore, it is often useful in urban landscape because usually we situate ourselves in the middle of the street to paint an urban view, looking down toward the end of the street. The streets are almost always straight, made up of parallel lines seeming to converge in a central imaginary point called the center of vision.

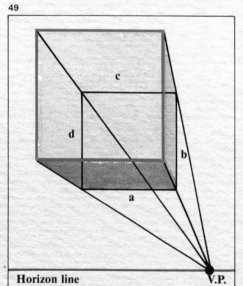

49

Horizon line V.P.

50

We are going to try to clarify all of these ideas with examples. To begin with, remembering Cézanne's advice about simple geometric shapes, we draw a cube in perspective. The cube can be used as an excellent example to explain the construction of an object in perspective graphically. And it can be seen as the reduced version of a building. Therefore, we draw a cube in parallel perspective. Pay close attention to the step-by-step explanation accompanying the sketch (fig. 49).

First, locate the horizon, a side-to-side line, at eye level. Then imagine a cube situated above it. (It could also be below.) One of the characteristics of parallel perspective is that one of the cube's faces is in front of you, the view-

er. You see it as it is, without distortion. In other words, you see a perfect square. Another characteristic is that the vanishing point and the center of vision are the same. Locate this point along the horizon (V.P.). Now draw one of the cube's faces, facing you, above the horizon; it's a square (shown in light blue). The next step is to draw four lines leading from the four vertexes (corners) of the square to the vanishing point.

find the lines ''a'' and ''b,'' by eye to define the bottom and side faces of the cube. To see through the cube, we drew lines ''c'' and ''d.'' In the photograph of the city (fig. 50), using the same system, we have placed some cubes to show perspective. We kept the horizon line and the vanishing points in mind, and made sure that the ''parallel'' lines met at the vanishing points.

Figs. 49 and 50. Drawing a cube in perspective is easy. First find the horizon (in red) and the vanishing point on this line (V.P.). Now draw a square like the one facing us. Next, draw four lines that start from the four corners of the square and run to the vanishing point. Finally,

Draw a horizontal line (a): the bottom face of the cube. And now draw the vertical line (b), which is the one that completes the cube's shape. Then draw lines c and d, which describe the cube as if it were made of glass, as if we were seeing through all the faces and edges.

If we observe the adjoining photograph (fig. 50), an urban view, you will see that it is a typical example of parallel perspective. We have marked the horizon, and the center of vision and the vanishing point, which are the same. Later, check to see that all the parallel lines belonging to windows and doors, roofs and display windows, fuse in an orderly way at the vanishing point. They "extend," meaning that they converge at this point, that they seem to be heading toward this point. We have drawn some cubes using this horizon line and the vanishing point. Some cubes are situated in space as if they were a child's blocks, for example. Now imagine where to situate these lines and points in Plana's painting (fig. 51), and notice that the vanishing point is not found in the center of the painting, but on the side.

Fig. 51. Manel Plana. *Riva degli Schiavoni Venezia*. In this beautifully constructed watercolor, Plana arrives at the vanishing point intuitively. Mentally find this point by extending the lines that converge on it.

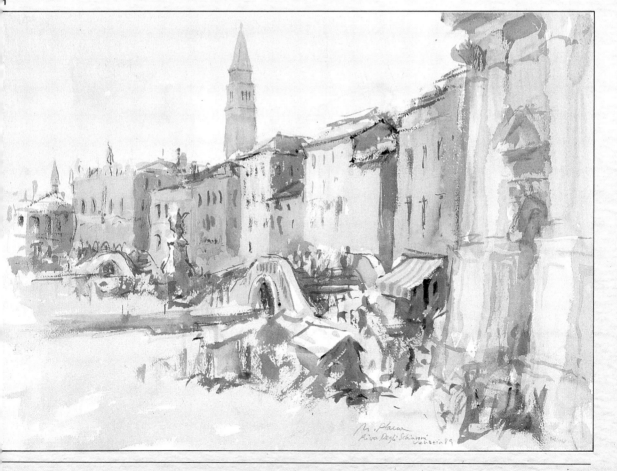

Oblique perspective

In an oblique perspective, the object being depicted—a building in this case—is shown at an angle. Here you see the corner of the building, or two sides of it. To obtain an accurate perspective, you need to draw the parallel lines from the vertical edge, or corner, to the vanishing point—there are always two vanishing points in an oblique perspective. In this case, the vanishing points go off the page. Notice also how the horizon and point of view intersect. Study the examples on this page carefully. Next we will go through the steps of how to draw a cube in oblique perspective.

Fig. 52. To draw a cube in oblique perspective, find the horizon and the two vanishing points (one closer to the point of view than the other).

Now draw a vertical line for the cube's edge closest to you. From its top and bottom, draw lines that meet at each vanishing point. Then

draw lines "a" and "b" to form the cube's sides. Now draw lines from the tops of "a" and "b" toward the vanishing points further away. The

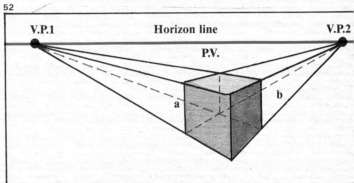

Fig. 53. We have drawn parallel lines that converge toward both vanishing points on the photograph (though they don't fit on the paper). In red is the horizon line. Look at the construction of the two cubes. Look also at the reflections in the water. They follow the same rules.

upper face is drawn. You can also draw the line that cannot be seen in an ordinary cube, as if the cube were transparent so that you can see the construction.

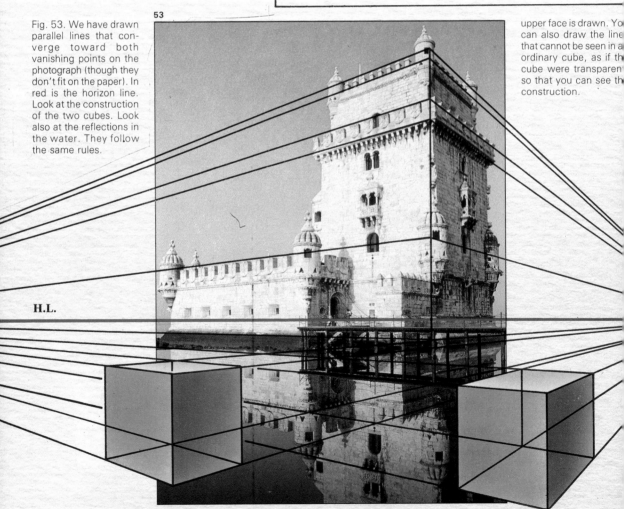

Fig. 54. Manel Plana. *St. Mary of Giglio Venezia.* In Plana's watercolor of beautiful reds, siennas, and oranges, with its strong lighting on the left side. The buildings are intuitively constructed, and both vanishing points are kept in mind.

In oblique perspective neither face of the cube faces us; all the faces appear distorted (although we know in reality that they are perfect squares). The only thing we will be able to see correctly is one of the edges of the cube, a vertical edge. We begin from there to draw our cube.

We position the horizon line above where the cube will be. The vanishing points are both on the horizon, one closer to the center of vision than the other (see fig. 52). First we draw the edge closest to us, a straight vertical line, slightly separate from the imaginary vertical one that corresponds to the center of vision.

Now we must draw vanishing lines right and left of the edge, as well as above and below. Some vanish at one point, and others at another.

Next draw by eye the two lateral faces of the cube, with two vertical lines, (a) and (b). Then draw the corresponding vanishing lines to obtain the upper side of the cube. Also, draw the unseen vanishing lines, as if the cube were made of glass and the lines could be seen, in order to check that the drawing is not excessively distorted. Now notice in the photograph on the previous page (fig. 53) how we have drawn the horizon line and indicated the vanishing points, although they don't fit on the paper.

They exist even if you can't see them; you can check by extending the lines off the sides of the image.

Later, try to imagine, on Plana's painting (fig. 54) where you would put the vanishing points and the horizon line. Try placing a big piece of tracing paper over the photograph. Keep in mind that the painter is more intuitive than exact.

54

Aerial perspective

Aerial perspective, with three vanishing points, allows the viewer to see no undistorted line. This would be your view if you were looking down from the terrace of a tall building. To get an idea of this, look at figure 55. Again we'll use a cube, which we know has only parallel or perpendicular edges. Knowing that helps us understand the distortion of the vanishing lines, which meet, in this case, at three different points.

One of these vanishing points is not located on the horizon but way below; on it converge the vertical lines of the cube. This type of perspective is hardly ever used in artistic composition—it's more a photography tool used to produce special expressionist effects.

In the painting below with the Venetian theme (fig. 56), Manel Plana uses aerial perspective for its softening effect. It's good to know about this technique, in case you want to refer or use it at some point.

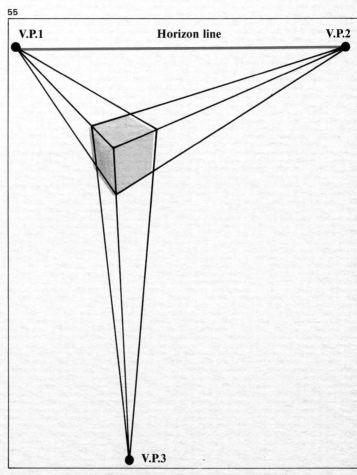

55

V.P.1 Horizon line V.P.2

V.P.3

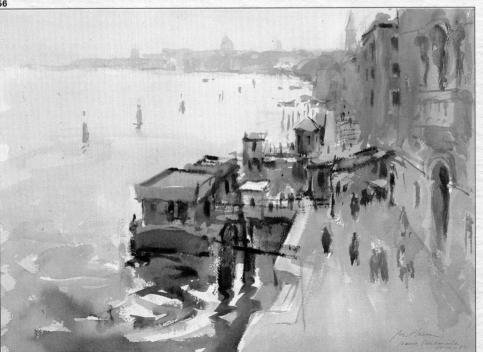

56

Fig. 55. In aerial perspective, a cube is constructed with three vanishing points. The third vanishing point is not found on the horizon; it's the vanishing point of the vertical lines.

Fig. 56. Manel Plana. *Nuove fondamenta, Venezia*. Normally, the painter doesn't remember the third vanishing point and softens the vertical lines that meet there. This happens in this watercolor, when the painter's point of view is raised.

Guidelines

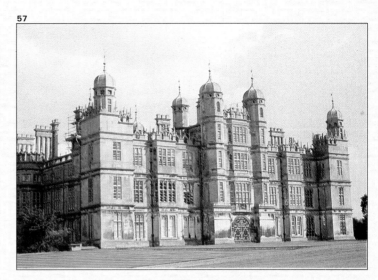

57

When we were talking about oblique perspective, we referred to a photograph and painting by Plana in which the vanishing points existed off the paper. When this happens, and it often does, it's difficult to establish the correct perspective by eye for walls, roofs, doors, windows, and chimneys. And this is especially true if we draw from memory, with no model in front of us.

We offer a practical solution for this by way of the sketches on this page. They show a way to establish a system of guidelines that allow us to position our subject's parts correctly.

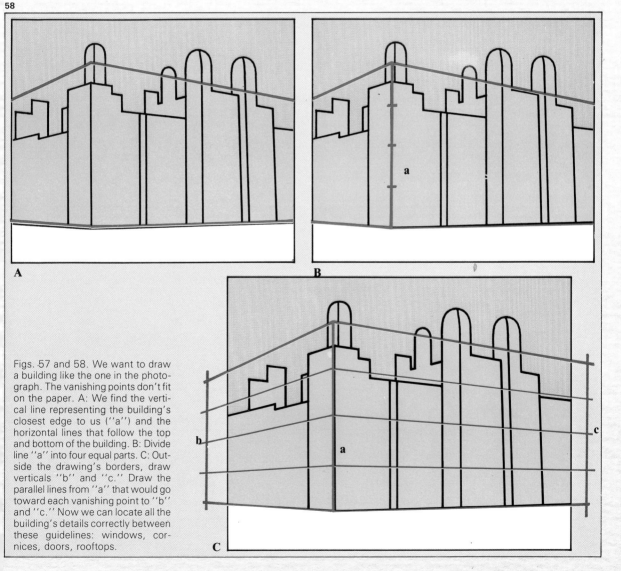

58

Figs. 57 and 58. We want to draw a building like the one in the photograph. The vanishing points don't fit on the paper. A: We find the vertical line representing the building's closest edge to us (''a'') and the horizontal lines that follow the top and bottom of the building. B: Divide line ''a'' into four equal parts. C: Outside the drawing's borders, draw verticals ''b'' and ''c.'' Draw the parallel lines from ''a'' that would go toward each vanishing point to ''b'' and ''c.'' Now we can locate all the building's details correctly between these guidelines: windows, cornices, doors, rooftops.

Illumination, contrast, atmosphere

60

The objects that we draw or paint—since when we paint we draw at the same time—whether teacups, cars, or cathedrals, are bodies located in space. Our discussion of perspective has shown us how we create the illusion of solid objects in space. Now we must remember that we see these objects because they reflect light. This is another observation that seems obvious. It is this light that gives shape to the objects we see. When we represent the light, we also represent the bulk of objects. Whatever our light source may be, a light bulb or the sun, it is reflected in some parts of the objects in our picture and not in others. Light is what produces the shadows and colors in shapes. On a cloudy gray day everything seems flat; on a sunny day everything takes on volume that we must know how to represent.

Plana likes light, clear days. He is inspired by strongly lit subjects with sharp contrast. Yet he uses watercolor more than any other medium. Surely it isn't by chance; you will see that watercolor is a magnificent means for representing light.

What is illumination? This word, which painters use so often, means the representation of the different tones ranging from the brightest white to the darkest black. It means using light to represent the volume of the objects depicted and the tonal relations among them. To illuminate means to compare and relate variations in light.

In this case, the questions we ought to ask ourselves are: What is the darkest part of the subject? Which are the blackest areas? What is the lightest, the whitest part? Which are the intermediate tones?

Our response to these questions should be directly on paper, with a pencil, charcoal or ink or watercolor. First, we notice and locate the grays, which are more or less light and dark, occupying places in every portion of the theme. You can begin a drawing by resolving the structure with lines, sizing up dimensions, establishing correct perspective—and you can also illuminate. First, locate the large color areas, and define the lights and darks in general. Later, make changes in the smaller areas inside the larger areas.

59

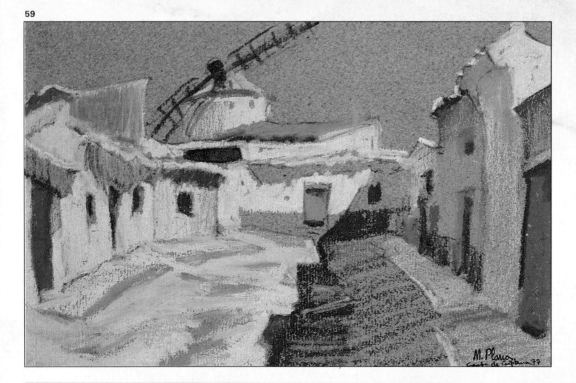

M. Plana

Look for the gray that is found in the middle of the large shadow area. You will discover that a light in the shadow area is never as light as where the object is illuminated. Always compare to see if there is something out of place.

From this point on, we can solve problems related to contrast and atmosphere. We are going to analyze these issues more specifically when we discuss color.

Fig. 62. Manel Plana. *Grey atmosphere*. In this case we are dealing with a cloudy day: The contrast is not strong, and the medium grays construct the theme. In order to paint this almost monochromatic watercolor, the painter must compare each illuminated area with an other, seeing where the white is whitest and the black, blackest.

61

62

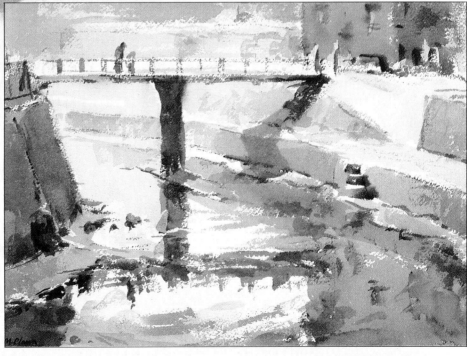

Fig. 59. Manel Plana. *Cripana Countryside*. Pastel on gray paper. This pastel of Plana's is useful for showing illumination. There are two important color areas that define light and dark: the white of the pastel on the left and the dark gray of the paper.

Fig. 60. This gouache by Plana is also an example of illumination. Notice the white of the paper, and the medium tones in the shadows.

Fig. 61. Manel Plana. *The Stream*. Drawing in black pastel. The contrast of a sunny day is expressed with a background of light paper and thick lines.

Sketches: the drawing as a search

Plana, the artist who joins us as we travel through these pages, dedicates a great deal of his time to drawing. In fact, Plana begins his paintings by drawing. Not only because he knows that when he finally paints the watercolor, he must know his theme well enough to resolve things with confidence and spontaneity, but also because he enjoys it.

I have been leafing through a pile of notebooks of sketches that Plana has been filling over the past twenty years. For me, as it would be for any painter, it is fascinating to look at these little jewels. In reality, they reveal an artist's entire process—these little works of art that are almost never exhibited.

We must realize that the paintings we see exhibited here weren't born from nowhere; reflected in them is a great deal of thought and apprenticeship.

63

Fig. 63. Manel Plana. *Sitting Muslims*. Some typical Moroccan characters are caught here by Plana's quick hand with a brush and sepia watercolor.

Sketching is necessary. Ask Plana about it. Not only is it necessary for broadening your knowledge, but it's also necessary for feeling the intense happiness of creating something without the fear we all have of the absolute end of a painting. You have to be at ease with drawing in order to understand how to resolve a work of art.

For Plana, the sketch also becomes the essential instrument for selecting a composition, for changing a theme, and for cutting it, as you will see later in this book. Now simply enjoy these sumptuous sketches—some in pencil, others in gouache. Take a soft pencil and a pad 8 × 10″ (20.3 × 25.4 cm), 5 × 7″ (12.7 × 17.8 cm), or 10 × 15″ (25.4 × 38.1 cm), and go out to the street or on the balcony and start to sketch.

Soon we will discuss making color sketches, since watercolor is appropriate for that, and we will discuss what must be resolved in a sketch and what too much resolution is. At the moment, though, it's enough to remember all that we have indicated with respect to the drawing as a valid sketch. It's not important to get involved in details. Also, if we draw on a small scale, the superfluous won't fit.

Try it!

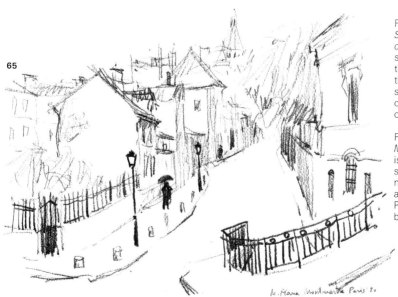

Fig. 64. Manel Plana. *Sketches of La Domencia*, Venice. Here Plana sketched in pencil and then used watercolor. In these two versions of the same theme, he finds in one what is lacking in the other.

Fig. 65. Manel Plana. *Montmartre, Paris*. Here is another of Plana's sketches, from an older notebook. But ten years ago, as well as now, Plana sketches his theme before painting.

Painting with one or two colors in gouache is an intermediate step between drawing and painting. The technique is exactly the same as in watercolor, but you have to achieve all the shades and nuances with only one or two colors, water, and the white of the paper. Gouache was used even when nobody was painting in watercolors: Rubens and Rembrandt painted many gouache sketches, as did Canaletto and Guardi in order to study urban landscapes. Claude Lorrain and Henri Poussin also painted gouache landscapes outdoors.

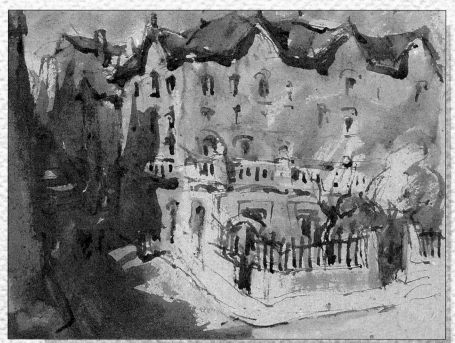

66

Gouache

Gouache for sketching

The gouache sketch is a technique halfway between a drawing and a watercolor. It can be considered a drawing because only one or two colors are used in different gradations with water—in other words, the sketch can be done in monochrome. But it can also be considered painting because the work is done with a brush, with a color. In short, as Jean-Auguste-Dominique Ingres said to his students, "one paints as one draws." The truth is that it's not so important to classify and define the technical limits of drawing or painting as it is to know how to use both.

previously applied, as you can see in figure 70.

We will explain all this now in hopes that you will try it at the same time.

To obtain a whole range of tones beginning with the color that comes out of the tube, the only thing you need is water. The more water you use, the less intense the color—the lighter, the more translucent.

You can try this gradation of color with any tube of paint, getting a variety of tones that range from close to the white of the paper to, as shown here, an intense blue or a dark earthy color.

Fig. 66. (Previous page.) Manel Plana. International Hotel, Puigcerdà.

Fig. 67. Manel Plana. Stairs in a Street of Irún. A black gouache sketch of a simple theme.

Fig. 68. Here is the illumination scale created by diluting black with water. These gradations are valid for representing any theme, regardless of color.

67

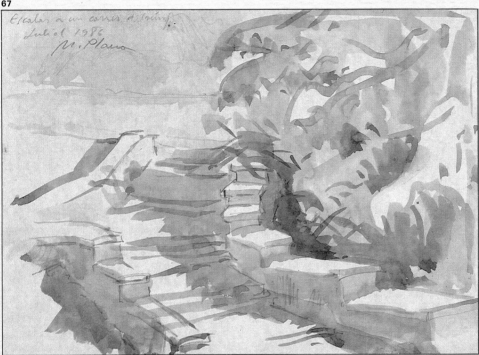

68

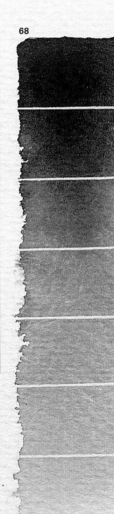

What is sure is that the gouache is almost watercolor. It is the perfect exercise to begin to know this medium.

You will draw or paint with one or two colors diluted with a greater or lesser quantity of water, obtaining a gradation of tones with the aid of the white of the paper, using transparent layers of color.

By "layers" I mean coats of translucent color, applied directly on the paper or on a previous coat of paint. Layering offers new tones or reinforces what was

It doesn't matter which color you use when you sketch with gouache, though normally dark colors are best because the variety of tones is more readily apparent (see fig. 68). Remember that, just as in watercolor, the whites should be the white of the paper, so reserve those parts you want to keep white. You simply do not paint those areas; you leave them without color.

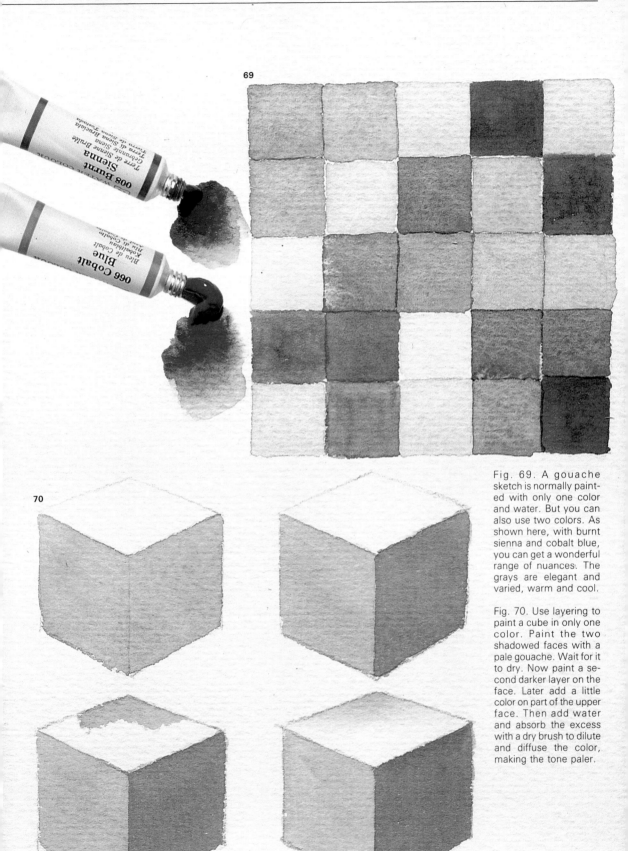

69

70

Fig. 69. A gouache sketch is normally painted with only one color and water. But you can also use two colors. As shown here, with burnt sienna and cobalt blue, you can get a wonderful range of nuances. The grays are elegant and varied, warm and cool.

Fig. 70. Use layering to paint a cube in only one color. Paint the two shadowed faces with a pale gouache. Wait for it to dry. Now paint a second darker layer on the face. Later add a little color on part of the upper face. Then add water and absorb the excess with a dry brush to dilute and diffuse the color, making the tone paler.

Exercises

71A

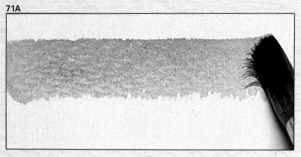

71B

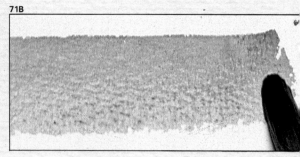

71C

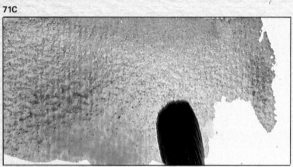

71D

72

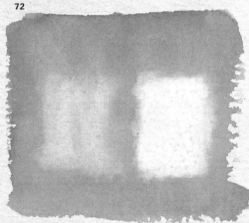

On these two pages, we are going to suggest that you learn four basic exercises for gaining control in this medium. These exercises are exactly the same for learning to paint a watercolor and therefore it is necessary to master them, although it is difficult at first.

Paint a uniform medium-blue area (see figs. 71A–71D): The blue area consists of only one flat color, without variations in shades. To prepare the color, dilute it until the desired tone is achieved (fig. 75). Try this on a separate sheet of paper. Use a small piece of paper. Set it up on an inclined board. Load the brush and very decidedly paint a horizontal fringe, beginning with the upper part (71 A). No-

tice how a part of the gouache accumulates immediately in the lower region of the brushstroke. It doesn't matter. Return to the work of loading the brush and paint another fringe (71 B). When too much paint accumulates in the lower part, use the brush vertically, spreading out the color toward the bottom (71 C). When you reach the end of the area that you want to paint, soak up the leftover paint with a dry or wrung out brush, which acts like a sponge (71 D).

Leaving light or a white in a recently painted area (fig. 72): Suppose that you want to get white or add light to a recently painted area, something that happens frequently when you paint in watercolor. You wet the brush with clean water and put it on the area you want to wash out. Wait until the water dilutes the paint that's underneath it, dry the brush, and leave it on this area again. As before, the brush acts like a sponge to carry away the water mixed with pigment. If you want a very light area, repeat this operation several times.

Fig. 71. To paint a regular and uniform area in watercolor, you have to follow the process shown in the photographs.

Fig. 72. In order to absorb a color in an already dry painted area, you have to wet the brush in clean water and paint the area that you want to make lighter with water. Wait until the water dilutes the color. Use a dry brush to absorb the liquified color. The whiter you want the area, the more you have to repeat this method.

Paint a continuous gradation (figs. 73A–73B): First paint a dark area off to one side (73 A). Next, clean the brush and, with clean water, dampen the entire area that will contain the gradation leading up to the dark spot. From this point on it's a question of mixing the first dark color area, which ought to be kept wet with water, with the light area. First, go to the middle of the area, and then go back and forth between areas, soaking up color with a dry brush and adding water until the gradation is continuous.

This exercise is difficult. It's possible that if you haven't done it before, it won't turn out well the first time. Go easy! Just repeat it. Paint layers (see fig. 74): Painting in gouache or watercolor requires superimposing tones to adjust shapes and illuminate them correctly. Paint over a dry light-colored area, superimposing another layer of the same color. The color will change; it will be darker. Study this process in this detail. But please remember, that in a good watercolor, the tones are painted on the first try, without superimposition of a great many layers of paint.

73A 73B 73C

Fig. 73. Try this exercise described in the text even though it's not easy. Repeat if necessary.

Fig. 74. Manel Plana. *Plaza in Albarracín*. In this detail of a gouache by Plana, we find much layering. But Plana used three layers sparingly because the beauty lies in not overworking this technique.

Fig. 75. Keep a spare sheet of paper on hand to try colors and degrees of wetness, and so on.

75

74

Manel Plana's gouache sketches

Whatever the medium, each artist puts his personal stamp on his work. When you paint a gouache or a watercolor, you will do it in your own way, whether you want to or not. On these pages, we will show you some of Manel Plana's gouaches. Plana painted these pictures with diluted watercolor or diluted ink, which actually are very alike. As you can observe, Plana's favorite color is sepia, with shades running from ochre or light pink to a very dark brown.

For Plana, the gouache is a way to draw-paint, to make sketches, to express a theme. Plana uses this medium with the same ease with which he draws in pencil. He feels that the gouache is like drawing with watercolor, faster than painting and with different results. It's easy to understand why he is so interested in this medium; Plana always

represents volume by way of lights and darks. Since gouache is a monochromatic technique, the artist can use it to sum up the essential lighting of a subject. For Plana, lighting is the principal organizing concept when he makes a watercolor painting using a variety of colors. Thus gouache is like a drawing to him, done with water and brush. Plana uses it to make studies for his paintings, and also for its own sake—with urban landscape themes.

With regard to the gouaches shown here, notice the different treatments that the artist uses to express each aspect of the theme: fine brushstrokes, small color areas, large areas of light, the whiteness of the paper, and layers of paint that are never excessive, since they are used sparingly.

Fig. 76. Manel Plana. *Albarracín*, private collection. This gouache is not a sketch but rather a finished work in its own right.

Fig. 77. (Next page.) Manel Plana. *Sketch of Montblanc*. This very small gouache is a sketch where the brushstrokes synthesize the composition.

Fig. 78. (Next page.) Manel Plana. *Mohamed V. Tetuán Avenue*. Here is a sepia gouache, with a wonderful use of whites to define the theme: the houses and the awnings.

76

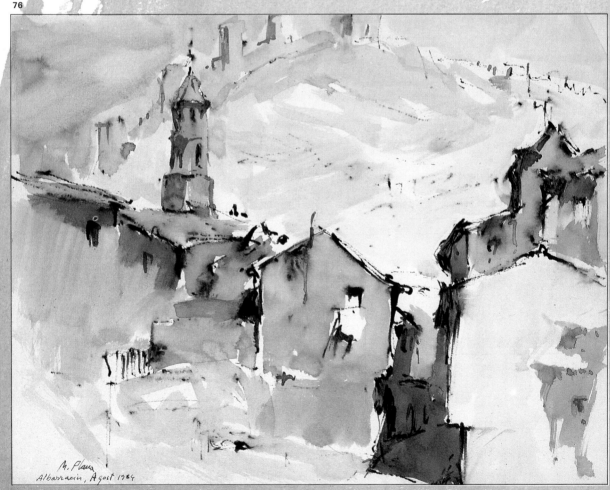

These gouaches are notes that were painted outdoors. They are constructed around the subject's illumination. Plana always saves the white of the paper for the lights, which comprise a major part of his theme. Notice how he uses the whites for contrast to describe the awnings, walls, and streets.

Fig. 79. Manel Plana. *Riva degli Schiavoni, Venice*. A gouache on paper that works even though no one would think a monochromatic sketch on paper would do this theme justice.

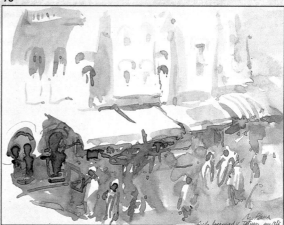

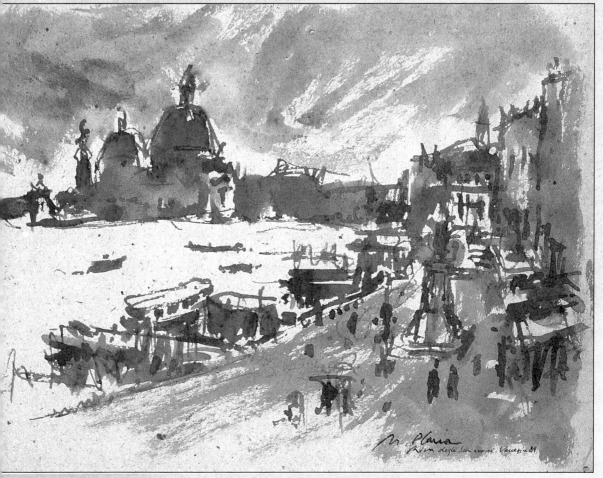

Nevertheless, I will
pass through the failures,
because I believe that in
working with watercolor
there is a demand for
great skill and quickness.
The material should be
partially damp in order
to achieve harmony, and
this doesn't leave much
time for reflection.
 —Vincent van Gogh

Don't be afraid of
failing. Work and enjoy
this refreshing and
transparent and difficult
medium.

80

Watercolor

Watercolor as a medium

Watercolor involves the act of painting with water *par excellence*. It has the properties of water: It's calm, soft, sensual, transparent. It permits a type of integration among the colors, a gradation or union that practically happens on its own. Nevertheless, like water, it's unpredictable and potent; it follows its own laws and its own paths. Therefore it is absolutely necessary to control this medium, the mixing and quantity of wetness. All watercolor needs is a little help, not the tortured kind that carries it off course.

We all know the force of water, its resistance to being dominated. Of all the painting media, watercolor is perhaps the one that demands more training from the painter than any other and a good basic knowledge of the material as well as a mature quickness of execution.

When we paint exclusively in watercolor, that is when we paint with all the colors, new questions arise from those we have seen with gouache. We must learn, for instance, about mixing and superimposing the tones.

Whatever you may think about it, watercolor is an open medium that permits a great deal of variety in technique.

To begin with, we can distinguish between painting on dry and painting on wet surfaces. The "dry" watercolor is not a special technique; it's the traditional way to paint a watercolor. We call it dry, only to distinguish it from the wet method which *is* a special one. Painting on dry surfaces means exactly what it says. You must wait until a layer of colors dries before you superimpose. If it fits, a layer or coat of color can be added. It's better, for this reason, to make a mistake of working too light rather than too dark.

Fig. 80. (Previous page, Manel Plana. *Market i. Tetuán*. Detail of a water color sketch.

Fig. 81. Manel Plana. *Pc ble Sec, Barcelona* This watercolor won a important award. Th light, the color, th atmosphere contamina ed by the big city on sunny day are perfect— as is the technique.

Figs. 82 and 83. Mane Plana. *The Piazzetta Venice; Canal in Venice* Details of Plana' sketches done in Venice Notice how the painte superimposes dark ove light and not the othe way around. If he wer to do it the other way, n harm would result, bu the color would b different.

81

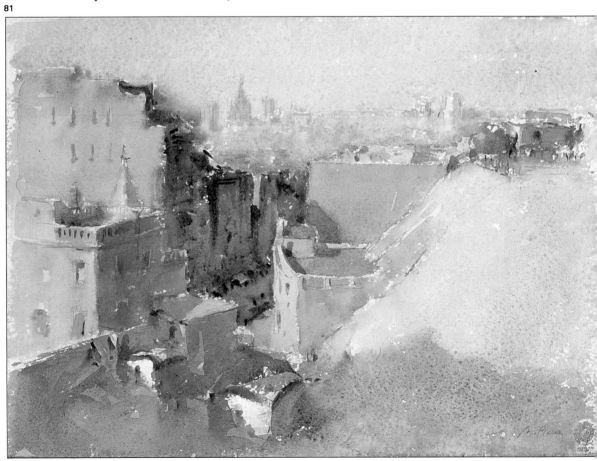

'o understand the transparent quality of watercolor, we ought to keep in mind ome basic rules.

. In watercolor, a dark color is usually uperimposed over a light color (figs. 82 nd 83).

2. It is necessary to go from less to more, from light to dark (figs. 84 and 85).

3. Whites and light colors must be reserved (figs. 86 and 87).

Figs. 84 and 85. Manel Plana. *La Cañada, Teruel*; *Bellmunt del Priorat, Tarragona*. Details of two landscapes. When painting in watercolor, you have to go from less to more. Look at the two ways in which Plana depicted the bell towers. Despite the differences, he always paints from less to more, from light to dark. You can always darken something light, but it is difficult and time-consuming to lighten something dark.

Figs. 86 and 87. Manel Plana. *Morocco sketches*; *Plaza Orfila. Barcelona*. A sketch of Morocco and a detail from another painting, each done in a different style. In the first case (fig. 86), Plana paints on paper already washed with pale colors. In the second case, Plana only suggests the stripes of the bench and the figures in the shade. He uses a few lines and that's it. This rapid definition is characteristic of watercolor technique, but it is so difficult that Plana merits special congratulations.

2

83

4

85

6

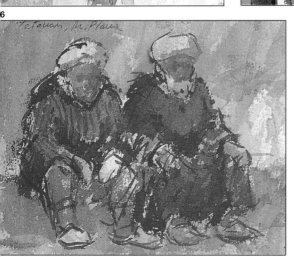

87

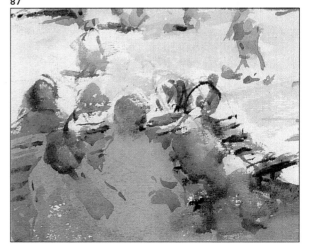

Wet watercolor

Using a wet surface for watercolor requires a special technique that has a lot to do with water and its effects. Perhaps for this reason it is a little more difficult than the traditional technique. Still, even if you are not painting in the wet style specifically, you will often use this technique, because painting directly over recently painted wet colors causes the spontaneous blending and running of colors. You must control this effect if you don't want to lose the shapes.

To paint a wet watercolor, you must wet the paper with a sponge or brush. Then you wait until it dries a little, until the paper isn't shiny, so that the dampness is not excessive. Then you apply color. Over colors already wet, paint other colors. Try it.

What happens? The colors mix. They blend with the white background or they fuse. The outlines mix; they become undefined and blurred.

You can absorb color with the dry brush technique where it appears necessary, as we have shown earlier. Then you can paint again over the colors that haven't dried yet.

Figs. 88 and 89. Manel Plana. *Village in Cerdanya.* Paint a cloudy atmosphere by using wet watercolor as shown here.

88

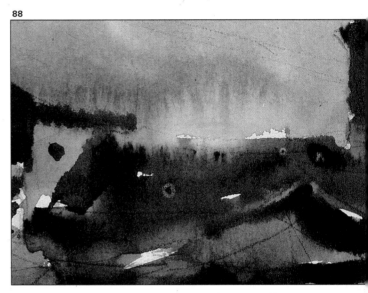

89

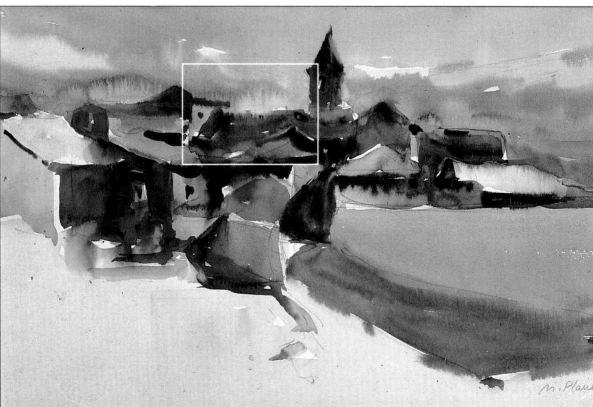

Most likely, your first wet-style water-color will not turn out coherent or well resolved. Don't stop trying. Very soon you will be able to combine this technique with the dry one, or use them separately. You will observe something very useful: Painting over a wet surface is very appropriate for representing skies, water, clouds, distant trees, a horizon where houses fade—whatever situation or object that doesn't have very defined outlines or a lot of contrast.

When you paint a wet watercolor, you must go fairly quickly. It is a process appropriate for capturing impressions, landscape moods, ideas about color, and light without much detail.

Look at the reproduction of Plana's paintings, including the detail (fig. 88), in order to see what we've been discussing.

Fig. 90. Manel Plana. *Sunset.* A combination of wet and dry water-color techniques are used by most painters today.

Fig. 91. Manel Plana. *Sunrise in la Mancha.* Just look at this painting.

90

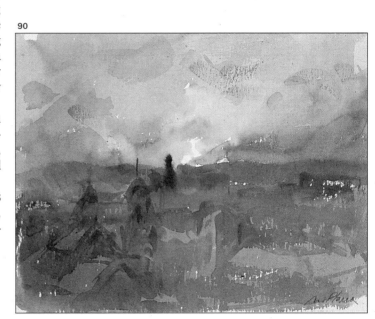

91

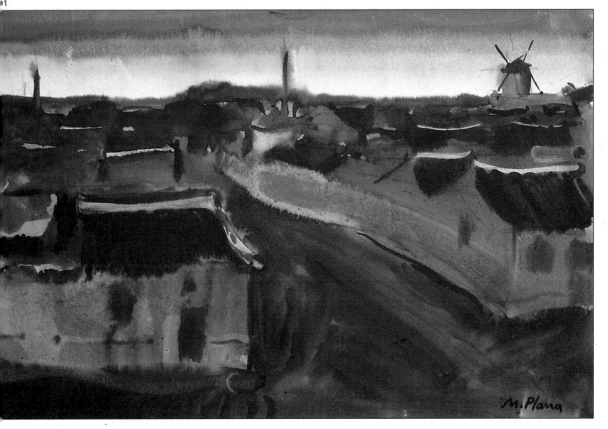

The whiteness of the paper

The whiteness of the paper is the one element that we have to keep in mind when we paint with watercolors, because in reality it is the only white we use. Because of its transparency and the fact that we see by way of color, this whiteness determines the tones we get.

In order to reserve whites, we work in stages:

First, leave out the white or very light areas; don't paint them.

Second, if these areas are very small or narrow, we can shield them from color in a number of ways. The most important of these are with masking fluids or wax (fig. 92 and 93). Or you can use tape if the paper is strong.

Third, if you need to open whites in an area that has already been painted, you can try a few things. If the area is already dry, use the side a knife or some sandpaper to rub off the color, or paint over the area with clean water until the color dissolves and you can absorb it with a

Figs. 92 and 93. You ca use two systems to leav out the whites. In fig. 92 a white wax has been ap plied. In fig. 93, rubbe cement has been ap plied. When you pain over either the water color doesn't penetrate

Figs. 94 to 96. In orde to open the whites on a already dry painted area you can scratch with a cutter or sandpaper o use water to dissolve th pigment and absorb with a dry brush.

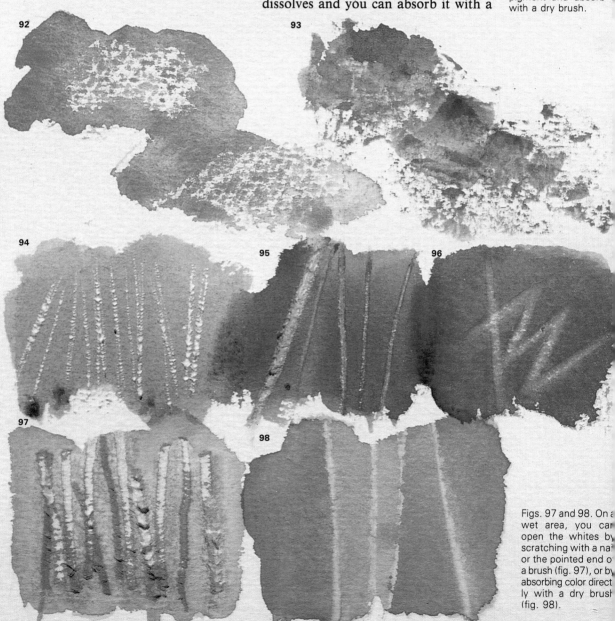

Figs. 97 and 98. On a wet area, you ca open the whites by scratching with a na or the pointed end o a brush (fig. 97), or b absorbing color direct ly with a dry brus (fig. 98).

Textural effects

dry brush or paper towel (figs. 94, 95, and 96). If the area is still wet, scratch it directly with a nail or with the wooden point of the brush, or absorb the color with a dry brush (figs. 97 and 98). For painting a rough texture on dry paper, you should use only a little water and rub the brush into the color until it is fully loaded. The grain of the paper will not permit the not-very-wet color to penetrate, so you get a rugged, undefined texture. A similar effect can be achieved by spreading a little salt on wet color; the salt will absorb part of the water and the color in an irregular way, resulting in an odd texture (fig. 99).

On a wet-colored area, if you apply a brush full of clean water, it will give you a special irregular texture, with varying shades (fig. 100).

This technique can be used, of course, on an already dry color (fig. 101).

Try using the same paper, but turn it in different directions to make uniques textures, which will vary according to how the paint runs. There are many other ways to create textures, as you will learn by experimenting.

Fig. 99. We created this effect by putting salt on a wet surface; when the watercolor dries, the salt will fall off.

Fig. 100. This texture was achieved by putting drops of water on a wet painted area.

Fig. 101. Drag a barely wet brush loaded with paint along the paper. Don't allow the color to penetrate the paper.

Fig. 102. Manel Plana. Detail. This effect was achieved almost by accident, on a piece of paper with a lot of grain. The paper was inclined, and watery paint was applied. It accumulated in the grain's valleys.

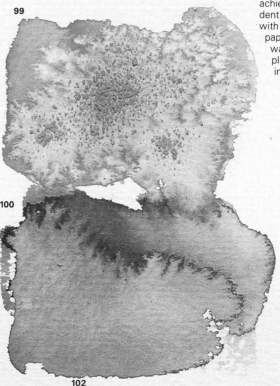

99

100

101

102

The question of complementary colors, of simultaneous contrast, and of the reciprocal destruction of the complementaries is the first and most important; another is the question of the reciprocal influence of two similar colors, for instance, a crimson and vermillion, a lilac pink and a lilac blue.

Certainly, by studying the color laws you can arrive at an understanding because you find beauty in the beautiful instead of having an automatic faith in the great masters; and this is very necessary now when one thinks about how arbitrary and superficial the judges are.

—Vincent van Gogh

103

Color

Color theory

We are going to talk a little about color, the element that finally defines a painting. The theory of color is an entire branch of physics; it is a very complex subject related to light. The spectrum of colors we see results from the refraction, or bending, of white light. We can see the spectrum, from red to violet, when we pass white light through a prism of glass, which bends the light rays. Similarly, when light passes through rain drops, a rainbow, a display of the spectrum, appears.

For our purposes, as painters, we need know no more physics than that. We will use colored pigments, and we will learn how they relate. Suffice it to say that what we will learn is based on the physics of color theory.

Of all the colors, there are only three that can't be obtained with any mix. Mixing a combination of any of these three together can produce the rest of the colors. For this reason these three colors are called *primary colors*.

The primary pigment colors:
• Yellow
• Magenta
• Cyan blue

On this page you see a color wheel. This is a circular arrangement of the spectrum in which colors flow into one another naturally. When you mix two primary colors together, you get a secondary color.
• Yellow and magenta yield orange.
• Magenta and cyan blue yield purple.
• Cyan blue and yellow yield green.

And if you continue mixing all these colors, you would get a never-ending range of colors, precisely what you see in the color wheel.

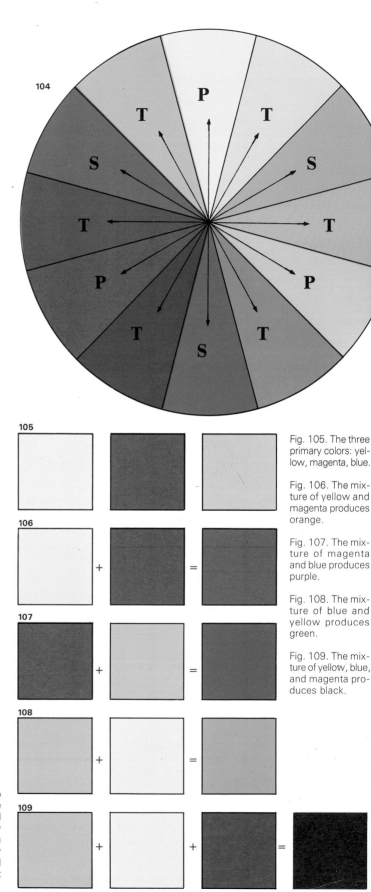

104

105

106

107

108

109

Fig. 103. (Previous page.) Manel Plana, *Barcelona*. Detail.

Fig. 104. Color wheel. The primary colors (blue, yellow, and magenta) are marked with a "P." The secondary colors, obtained by mixing two primaries (green, purple and orange) are marked with an "S." The tertiary colors, marked with a "T," are obtained by mixing a primary and the secondary closest to it.

Fig. 105. The three primary colors: yellow, magenta, blue.

Fig. 106. The mixture of yellow and magenta produces orange.

Fig. 107. The mixture of magenta and blue produces purple.

Fig. 108. The mixture of blue and yellow produces green.

Fig. 109. The mixture of yellow, blue, and magenta produces black.

Exercises

Fig. 110. The complementary colors are the ones found opposite each other on the color wheel. Yellow is complementary to violet, magenta is complementary to green, and blue is complementary to orange. Maximum color contrast exists between the complementaries: a red juxtaposed with green is very exciting. Contrasting colors really jump out at you—they even shock—but in different proportions they create a pleasant and bright visual sensation. This combination is often used by painters.

Fig. 111. Complementary colors are also used for painting shadows. On a wall like this, in a yellowish orange, the part in the shade contains a part of the complementary color, the violet. This is a detail of a painting by Plana.

Exercises

In order to make a color wheel to prove what we are saying, let's draw a circle and divide it into twelve equal parts like the one in figure 104. To paint the three primary colors with watercolor, use cadmium yellow medium, Prussian blue, and alizarin crimson. Paint these in the sections of the circle marked with a P. When these areas are dry, mix the colors two by two. Paint the resulting colors in the sections marked S, between the two colors that have given you the new color (the green goes between the blue and yellow, for example).

Continue to mix the resulting colors two by two, first on one side, then the other—the green with the yellow, the green with the blue; the blue with the violet, the violet with the crimson, and so on. Complete the circle.

The third colors that are obtained are called the tertiary colors. Of course it's possible to paint a circle with more divisions, until there is hardly any difference between one color and another.

Another important fact to learn is that: *mixing the three primary colors together gives you black.*

Look at the color wheel. The colors that oppose each other in the color wheel are called complementaries.

110

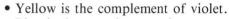

- Yellow is the complement of violet.
- Blue is the complement of orange
- Magenta is the complement of green

It's important for the painter to know the complementary relationships of the colors because:

- Complementary colors offer the maximum contrast (see fig. 110).
- Neutral colors result from mixing complements.
- To darken areas of color, you use the complementary colors (see fig. 111).

No color ends with itself, rather it depends on and is the result of the colors around it. Said another way, the important thing isn't this color or that one in a painting, but rather the relationship between the colors.

111

The warm range

To produce an example of a warm range, paint two squares exactly the same size in exactly the same color green. Later paint around one in yellow and around the other in blue. Notice how the green of the squares suddenly doesn't seem to be the same green. Yet you know that it's the same, because you painted it. The green that is surrounded by yellow will seem cooler than the other; the one that is surrounded by blue will seem warmer because it is in contact with a cooler color.

Now let's distinguish two types of relationships between colors: harmony and contrast. We already know what "harmony" means in music. When the word is applied to painting, it means that related colors belong to the same "family."

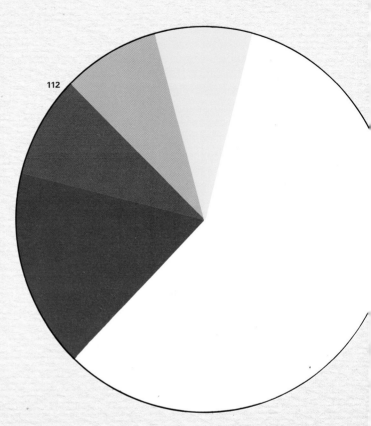

112

A family is a range of colors next to one another in the color wheel. And there is also harmony when colors contain roughly the same amount of light. Contrast exists between colors of different ranges. The best example of contrast is between the complementary colors (purple and green, for example), or between colors of different luminosity (white and black), or between colors of different "temperatures."

113

Fig. 112. The warm colors are the ones in the color wheel between magenta and yellow: oranges, yellows, and crimsons. But siennas, tans, some browns, some greens, and some purples or violets are also warm.

Fig. 113. Here is a warm range of colors that can be expanded extensively. All the colors we have named on the color wheel become paler with a little white added. This range is painted in watercolors with water added to get more variations. Try painting these and many other colors to get the most from your palette.

Fig. 114. Manel Plana. *Manzanero, Teruel*. This rural landscape is painted almost exclusively with pale warm colors. The shadows have some violet and blue. Keep in mind the kind of light that produces these colors—afternoon light.

We are going to discuss harmonic color ranges: On the color wheel, the colors that are close together in the circle form a "family." When you work with these colors, you can get variations by adding small amounts of black or using the white of the paper to adjust the colors luminosity. You can also add small amounts of other contrasting colors to the ones you are working with, taking care not to change the dominant harmony.

The warm colors are the ones in the wheel between magenta and yellow (fig. 112). These colors will remain warm, even if they are mixed with black, diluted with water, or contrasted with blues or violets. The warm range can develop any way you want. These pages show examples you can try for yourself (fig. 113).

In Manel Plana's painting (fig. 114) done almost exclusively in a warm range, you can discover additional warm shades. In a painting like this, with only warm colors, you can be sure that the colors will be harmonious. But you have to purify the colors, and take care with the darks and lights in order to describe shapes and light, and to give coherence to the painting. As you can see, warm colors used in an urban landscape generally implies afternoon light, dusk, or very early morning light, when the sun's rays are at an angle and quite red.

14

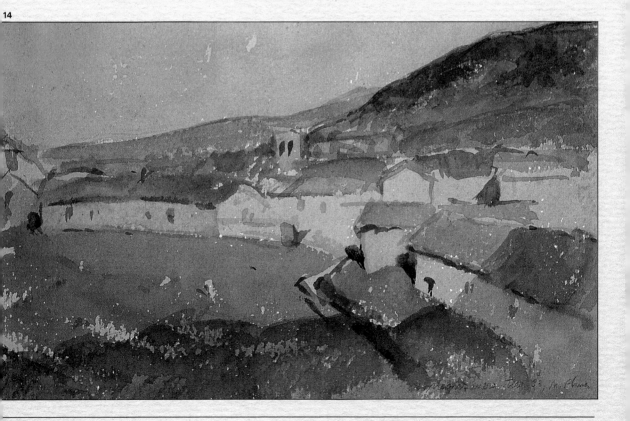

The cool range

Warm colors are made up mostly of reds and yellows; cool colors are those with a blue base. Nevertheless, in order to get wide ranges of color with distinct nuances, you must use all three primary colors and their derivatives. A blue can have a little red or yellow in it. It will be a blue that is warmer than a pure blue. Also, cool colors can be lighter and darker as well as warmer or cooler, relatively speaking.

Cool colors are in the green-blue-violet-gray family, but a yellow can also be cool; a lemon yellow is a cool color. It's a yellow that contains some green.

In this watercolor by Manel Plana (fig. 117), painted outdoors in a Catalan town, you can see the result of painting in a cool range rich in shades including brown, crimson, and red.

Before, we said that a color is nothing by itself—that it depends on what colors are around it. This observation pertains to both warms and cools. Colors seem more or less cool according to the "tem-

115

perature" of the colors that surround them. The siennas and tans in this painting have an outstandingly cool tendency, since they were composed with a great deal of blue. But they are surrounded by blues that are even cooler. They actually seem warmer than they would if they were seen alone. Check this out by covering blue areas of the painting with white paper.

116

Fig. 115. Cool colors are those in the wheel between yellow and violet. As we have said, this yellowish green can be considered almost warm, and so can violet, depending on the colors surrounding them. For example, if we painted exclusively with warm colors, and then add the yellowish green and the violet, they would be the coolest colors in the painting.

Fig. 116. Here is a cool range done with watercolors. You already know that you can augment these with many other shades. There are hundreds of blues and greens. And by adding water, you can get many other lighter colors. Notice that the pinks and browns that appear here lean toward the cool side.

Fig. 117. Manel Plana. *Sketch of Montblanc*. This watercolor is done in cool tones, with some warm ones for contrast. You get the sensation of a sunny morning, of a refreshing white light, with cool, transparent shadows.

However, the artist hardly ever uses just one range of colors to make a painting. For example, in a painting of harmonious blues, it is common to find warm areas that may even be pure and vibrant. I would also go so far as to say that this *should* happen, because only in this way can colors support each other, correctly complementing and enriching each other. With regard to the question of color "temperature," keep in mind that psychologically speaking the two inspire different moods. Warm colors are more intimate, more passionate. Cool colors are more distant, more relaxed. In this cool urban landscape of Plana's, the cool colors describe daylight hours when the sun is high in the sky, but the cool range also appears when the sunlight has disappeared.

117

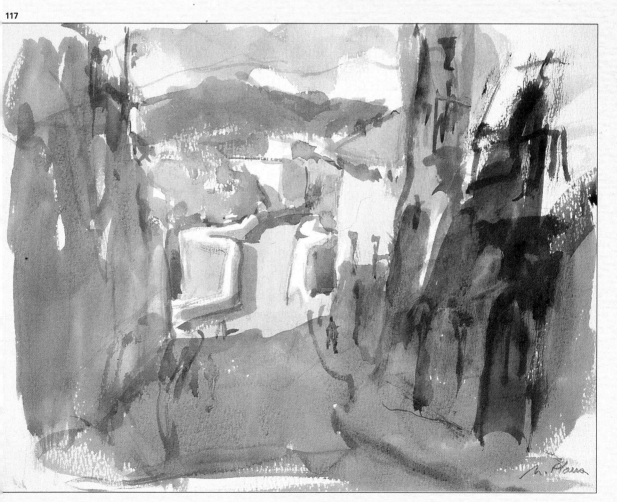

The grayed colors

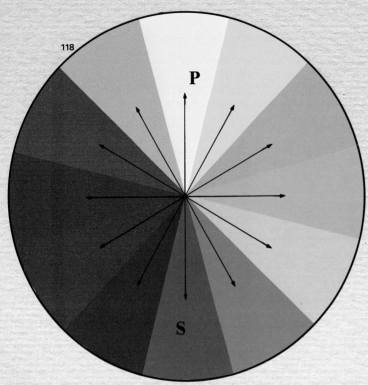

Figs. 118 and 119. A grayed color is the result of mixing two colors opposing each other on the color wheel in different proportions and adding white.

In watercolor, white is the paper. For example, if you mix yellow and blue (complementaries) and later add some water, you get this dull green.

The range of grayed colors is extraordinarily useful to a painter, whether he or she wants to paint with them exclusively or use them as an aid to complement or enhance other ranges and colors. In the urban landscape, this range is particularly useful, because in reality, city and town themes clearly have this gray tendency.

There is an infinite number of grays, greens, browns, chestnuts, dirty whites, gray-blues and violets, ochres and yellowish grays. It's a defined, delicate range that allows for a great deal of elegance and subtlety. On these pages we have some colors in this range that you can copy or alter as you wish. It's worth knowing about these grayed colors. They are useful for enriching, adjusting, and illuminating the warmer shapes and dark areas.

A grayed, or dull, color can be obtained by mixing two complementary colors in different proportions and adding a certain amount of white to the mixture. In watercolor it's enough to add some water to the mixture of the two complementary colors (fig. 119).

All the colors obtained in this way comprise the grayed range. It would be the same if we said that the mixture of two complementaries is the mixture of two colors opposing each other on the color wheel (fig. 118).

Why do we call the colors that result from these mixtures dull or neutral or broken? Because they have unequal parts of the three primary colors. (Take a look at the color wheel; you'll see that this is true.) And we already know that mixing the three primary colors gives us black.

So, all these colors are grays, they tend toward gray; they aren't pure or clean.

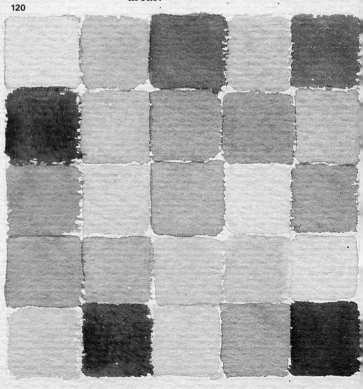

| WHITE OF PAPER | = | |

Do some tests: Paint a piece of paper with yellow. Wait until it is totally dry and then paint thin layers of blue, crimson, green, and violet over areas of the yellow. See what colors you get.

Fig. 121. Manel Plana, *Montblanc, Tarragona.* This watercolor is painted entirely with dull colors. Notice that besides being dull, they are cool tones of varied shades.

On the other hand, the grays can be more or less warm or cool. These two watercolors by Plana are painted almost entirely with dull colors, but one of them is obviously warm (fig. 122), and the other cool (fig. 121). This difference is of course due to the color that dominates each mix.

We already know enough about how to get a wide variety of colors, but we must add something that is important in watercolor: Since watercolor is translucent, color mixing is done on the paper, by superimposing one color over the other. In other words, not only do we mix colors on the palette, but we also mix colors by placing one layer of color over another previous layer of a different color.

121

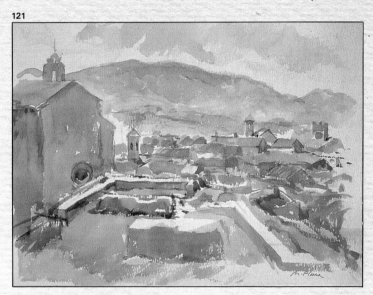

122

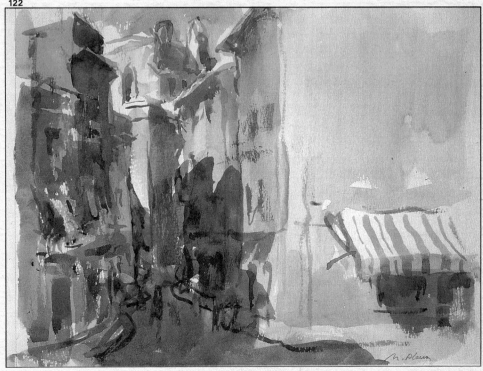

Fig. 120. The dull colors are "grays," —there are an endless stream of them. There are green-grays, blue-grays, pink-grays, ochre-grays, brown-grays, khaki-grays, olive-grays, and so on. You can paint any urban landscape with these. Try to paint a group of colors like this.

Fig. 122. Manel Plana, *Montblanc, Tarragona.* This is the same urban landscape in dull colors but with a warm tendency. There are brown-grays, ochre-reds and ochre-pinks, together with clean orange and sienna.

Atmosphere and contrast

"If you are very thorough and work with great detail, far objects will appear to be closer instead of distant. Try to pay attention to the distance of each object, and in the unclear and less defined edges, represent them as they are and don't overwork them."

Leonardo da Vinci

In Da Vinci's *Treatise on Painting,* a question appears repeatedly, one that obsessed him: The question of representing distance, of representing the air between the bodies like a veil that gets thicker with distance. Da Vinci concerned himself with how to represent things as close to reality as we see them, so implications of distance were naturally of great importance to him. The figures in his paintings seem to diffuse themselves in their environment; even more undefined are

the landscapes in the backgrounds of his paintings. In the same way he studied perspective, another tool for expressing depth, he studied how to solve the problem of distance with color.

He invented *sfumato*, the dissolving of outlines. Later, the Impressionists adopted, and adapted, this method.

The representation of distance by means of light and color is thoroughly pictorial. In order to understand it, you have to understand how shapes and lighting are created with color, with light and dark contrast and "temperature" variations. You must also remember that some colors are more intimate and some more distant.

Fig. 123. Manel Plana Bilbao. This watercolor is done in the wet technique, taking advantage of the watery qualities and mixing them on the paper. It is a beautiful expression of the charged atmosphere of an industrial port city. The heaviness in the air is evident, the outlines dissolve, and the silhouettes blur.

123

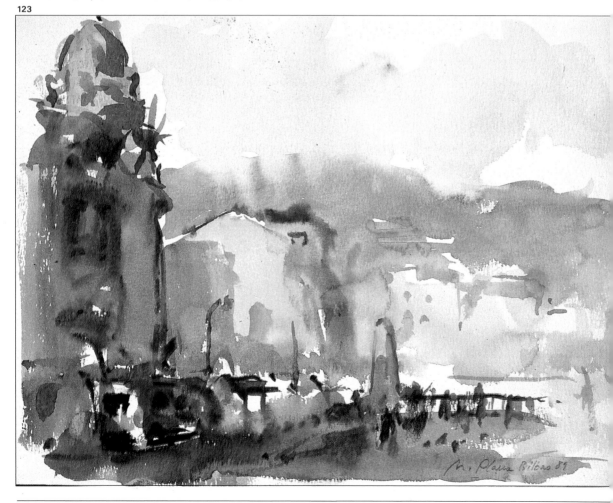

Fig. 124. Manel Plana.
Montblanc, Tarragona.
With originality and pre-
sion, Plana paints this
watercolor based on
color contrast: the
ranges and the blue vio-
ts. In the foreground
re light and dark, orange
nd violet. In the back-
round, the colors are
ale. They become
rays. The outlines dis-
opear in the distance.

Here are three hints about distance to keep in mind while you are painting a landscape.

1. The foreground is more defined than the background. It contains the maximum contrast between light and dark and the maximum color contrast.

2. In a more distant foreground, colors blend more into their surroundings. Colors appear grayer and duller. They have less contrast between them than close foregrounds.

3. Warm colors tend to be more intimate; cool colors, more distant.

These are valid hints, but, as Plana reminds me, all rules have their exceptions. In any urban landscape, you can have an intense red in a background, depending on how correctly you use it in relation to the rest of the painting.

Luckily, watercolor is a wonderful medium for expressing atmosphere. We can take advantage of the water in a watercolor to blur outlines, the same way we can use it to dilute colors. These two watercolors by Plana, vibrant with color. They were done swiftly, with great sensitivity, showing graphically the contrast in foreground and background—the humid and electrically charged air of a city port (fig. 123) or the clean, almost transparent air of a village in the interior of the mountains (fig. 124).

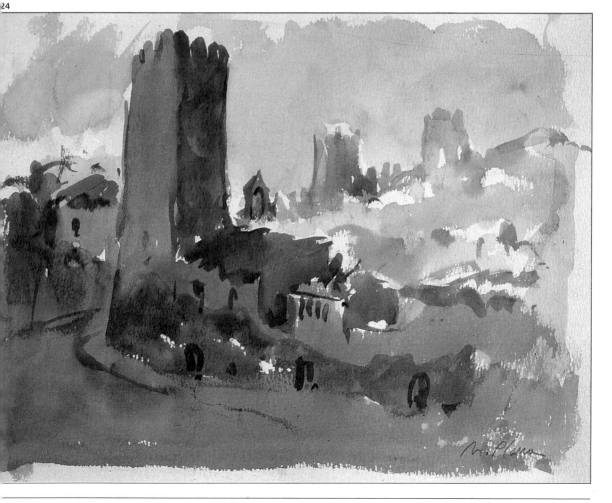

It's important to go out and paint with a desire to observe, with the mind and the eyes open to receive sensations. A city, a town, has so many elements, so much variety, that perhaps you should begin quietly, taking with you an idea of what you're looking for. You have to decide so many things! The best way is to begin painting a sketch while you look for the framework, the color, the composition. It's worth the trouble to stop and think and paint little notes, because later you can use them as a reference at home, or you can go back outdoors with a clearer idea and with some problems already solved.

This chapter is both a synthesis and an introduction: A synthesis, because in it we try to sum up what it is to paint an urban landscape; an introduction, because the questions we will deal with will reappear later on.

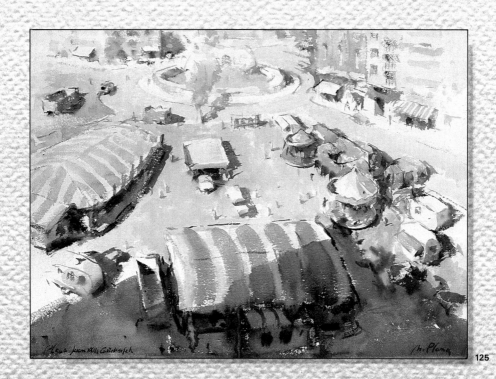

Manel Plana's work

The first impression

Painting is not copying reality, for one thing that would be practically and humanly impossible. No. To paint is to create, to project a personal vision, to present a concept through a particular subject. More concretely, painting is interpreting. To interpret can mean to invent, to add things, to leave things out, to broaden or diminish... depending on the subject and what it suggests.

As we proceed, let's remember the usefulness of color sketches. We'll begin with them. We have already written about the importance of sketches for maintaining an open hand, about small gouaches for drawing with watercolor, to learn control. We take notes in color to reproduce our first impressions about the subject, our first intuitions. Color notes can have little color but must be a summary of the painting you are planning. Sometimes color notes have only one subject, say the sky, a tree, the street, a window. Whatever it is, it must be a summary, not very detailed. The colors must catch the general idea.

Begin with a sketch, an outline of the composition, that reveals the basic structure of the theme.

—Use maximum contrast of lights and darks, without shading.
—Choose only a few colors to determine the harmony and contrast with clarity. Later, when you paint a watercolor, don't forget the sketch you've made. It's the surest way to liberate yourself from the "tyranny of the model." (Claude Monet spoke about the "tyranny of the model" when referring to the power of a live model that imposes itself on us, subjects and "distracts" us. It could also force us to lose our point of view, and carry us away with confusing details.) Make sketches because it's fun and useful.

Fig. 125. (Previous page.) Manel Plana. *The Fair, Castelldefels.*

Fig. 126. Manel Plana. *Sketch of Campogrande, Valladolid.* This sketch of a city park shows lights and darks in the colors of the trees and the background.

Fig. 127. Manel Plana. *The Cathedral, Tarragona.* A well-composed sketch.

Fig. 128. Manel Plana. *La Piazzetta, Venice.* A sketch done in Venice that shows the quality of color and the city's brilliant light.

127

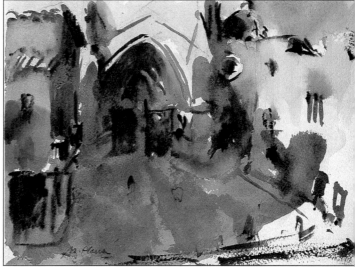

126

128

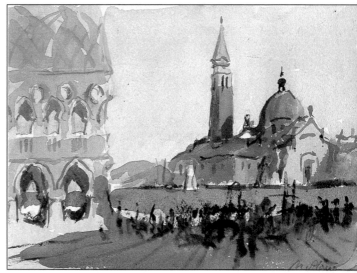

lana paints a lot of sketches, from little
otes on paper that don't measure more
1an 4 × 6″ (10.2 × 15.2 cm), with only
1ree or four colors (fig. 130), to sketches
1ore complex in architecture, lights and
arks, harmonies, and contrasts. Some
ketches can measure up to 12 × 16″
30.5 × 40.6 cm) or more (figs. 126, 127,
nd 130).

ook closely at the sketches on these
ages. They will help you understand the
eneral concept of sketching. Plana tries
) obey his initial impulse as much as
ossible, to develop the personal idea
1at he brings to a painting. He is often
1ccessful, but not always. Sometimes
e also feels dominated by the subject
1 front of him. He doesn't hesitate to
egin a painting over again if he finds
doesn't meet his expectations.

We will discuss his themes, composi-
tions, and ideas, and we will see how he
paints some urban landscapes. All of this
will permit us to enter into the painting
process, so that we can better understand
the general ideas we have presented.

Fig. 129. Manel Plana. *Venice Canal.* Another sketch done in Venice; from my point of view one of the best because of its originality of color, decisive brushstrokes, and almost abstract composition.

Fig. 130. Manel Plana. *El Forcall.* From a quick view from the car, Plana sketches the essentials in three colors, on a very small piece of paper.

Fig. 131. Manuel Plana. *Street in Morella, Castellón.* Sketch of a town in Catalunya.

130

131

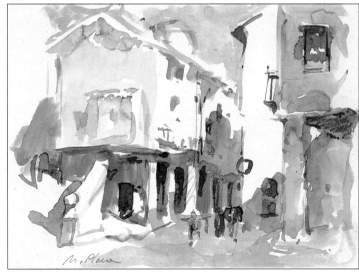

29

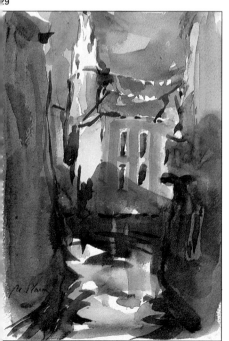

Selecting and composing a theme

How do we start painting an urban landscape in watercolor? Where do we start? When? Maybe these are questions you are asking. Decisions like these are basic for any artist. We're going to try to answer them using Plana as an example. Though our discussion deals only with the details of how Plana works, the idea is to give you some advice and suggestions, which you will be able to use yourself.

When you think of an urban landscape, even in the abstract, a wide variety of different themes come to mind. This is true because a great many things can be included in an urban landscape. Indeed, selecting a particular theme becomes a difficult and personal decision.

Plana has painted all types of urban

perspective. We must know what interests us about it: The people? The colors? The grandeur of the panorama? The distance of the vista?

In order to begin, we shall try to understand good paintings, old and new. We'll consider what is appropriate squaring off; how the painter has expressed his ideas; how you can say what you want to say. In the beginning, let's concentrate on simple themes like the one in figure 134, a street with shops. Plana positions himself in front of and above the theme on a balcony. He describes the street by superimposing the elements on it: the trees, the people, the doors and awnings of the shops. This is a simple composition based on horizontal lines that define the different distances in the painting.

Fig. 132, Manuel Plana. *A Terrace*. An outdoor café on a city promenade, not an easy theme. Plana uses blue shadows.

Fig. 133. Manuel Plana. *Crowds*. A celebration with people dancing or strolling. The background atmosphere of the plaza is the theme of this sketch.

Fig. 134. Manuel Plana. *Rambla, Terrassa*. The theme's apparent simplicity makes you wonder how he ever achieved enough artistic force or pictorial interest.

132

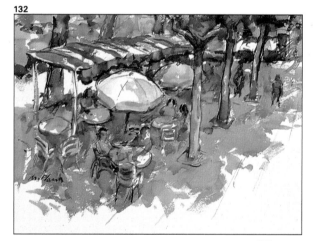

133

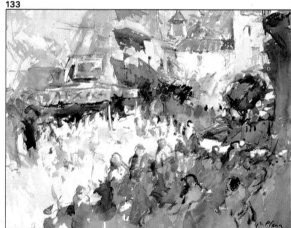

views. The paintings reproduced here, and others in this book, are ideas about landscapes. Take a look at them. There are both urban and rural landscapes with many, a few, or no people at all. There are panoramas in which a city is immediately recognizable by its principal characteristics: a terrace and a bar under some trees, a monument in a plaza, some shops on a street. Others show local color or industrial themes, like a train station or a smoke-expelling factory.

Choosing a theme doesn't end with the general choice of subject, of course. It's also necessary to decide exactly what is going to be painted and from which

134

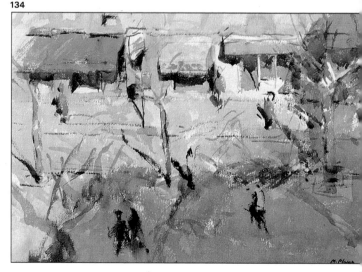

Another easy theme is a street observed from a sidewalk, with one side in the shade and the other illuminated by the sun. We're looking for themes that have clarity in their composition, that are geometric but not boring, with strong contrast between lights and darks, with an easy perspective that isn't too obvious, and with an interesting harmony of color. After you try a simple picture like one of these, try a noisy, crowded street; paint people sitting down or walking. Later, situate yourself on a rooftop, look around, and try to paint what you see. Perhaps you'll only see other roofs, or your view may be complicated by competing perspectives of streets, cars, and so on.

If you travel, sketch what you see to describe the differences between one environment and the other. Discover how the light differs from place to place, and how colors vary.

When you see an attractive theme, if you make a sketch and then paint it, you will see it more clearly. This is partly the result of taking your time to notice what

you see, and partly because you must compose your theme on paper.

To help in framing a theme, cut two angles out of black cardboard and hold them up as you select your composition. You use the angles to make a sort of window.

Fig. 135. Manel Plana. *The station, Irún.* Here is a modern urban theme. Plana takes advantage of the strong perspective force, the train tracks, and the uniformity of the color, to give us a sense of the scene.

135

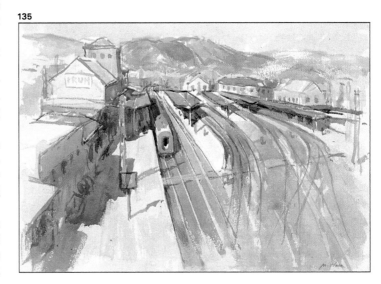

136

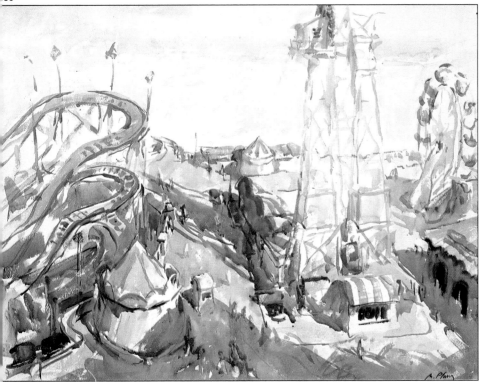

Fig. 136. Manel Plana. *The Amusement Park.* Plana always tries to look at classical themes with new and different eyes. One device he employs is looking at a theme from above. Another is to look for themes that haven't been painted very much—an amusement park, for example. We notice that the city, in the background, is diffuse and merges with the sky.

Composition, light, color

Suppose you have chosen a theme. You have gone out of the house with a drawing board or easel, paper, tubes of paint, and brushes, and now you are in the street or on the terrace, ready to paint. Ready to paint what? Where to start? The theme you have in front of you isn't one, but many. You can paint this little part, or a wide panorama. You can put your board or easel to the left or to the right.

Try different versions from different angles, with a pencil or watercolors, choosing one or another part of what you see.

137

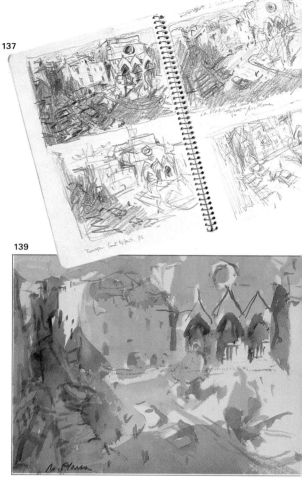

138

139

140

Figs. 137 to 140. Manel Plana. Sketches, studies and the finished work *Plaza Vella, Terrassa*. Sorry about the small size of these photographs. The important thing to notice is how the artist succeeds in defining the subject, the composition, and the colors in a series of sketches.

Figs. 141 and 142. Manel Plana. *Two studies of the Marcá Station, Falcet.* Plana tries to paint the theme at two different times: morning and afternoon. This forces him not only to vary his color ranges (cool and warm) but also to vary the composition because the shadows change shapes.

In other words, sketch.

This is what Plana did in the painting in figure 140. He solved the problem of composition and framing after drawing not one, but four sketches (fig. 137). Later, he painted two color notes, choosing colors and harmony: pinks, earthy colors, siennas, a quick dash of blue (figs. 138 and 139) while he defined the theme. Later, he painted the painting (fig. 140), which won him a prize in a painting contest.

In short, sketching helps you come to a decision.

changing the shadows and the colors (figs. 141 and 142).

Plana almost never does a watercolor without preparation. He sketches first to understand the theme and his particular interest in it.

You see here several decisions that Plana has made.

141

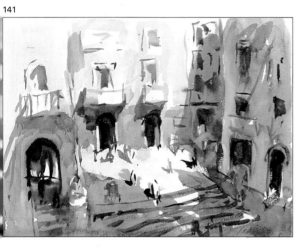

142

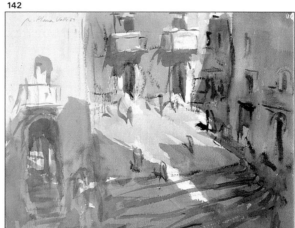

You must take advantage of the contrasts of color and light to prevent a monotone painting. You must represent the third dimension by means of perspective, if necessary. Try sketching the same theme at different times of day to get different illuminations. The sun moves,

Figs. 143 and 144. Manel Plana. *Two studies of a Plaza in Valls, Tarragona.* The consistency of Plana's work is clearly manifested when he paints two studies of the same theme. The point of view is almost the same, only the color range and framing varies.

143

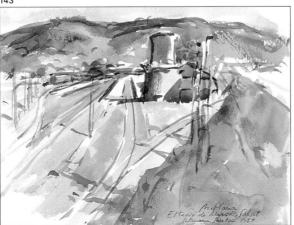

144

The process of making a painting is complex, although not necessarily long, especially if the painting is done in watercolor.
Nevertheless, Plana covers a wide territory in the way he prepares for what will be the final result.
Now you have enough information about how to paint an urban landscape. If you haven't already started, it's time to get down to work.

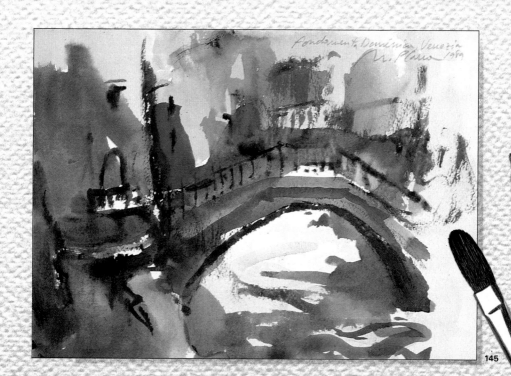

145

Painting an urban landscape watercolor

The theme: A street scene

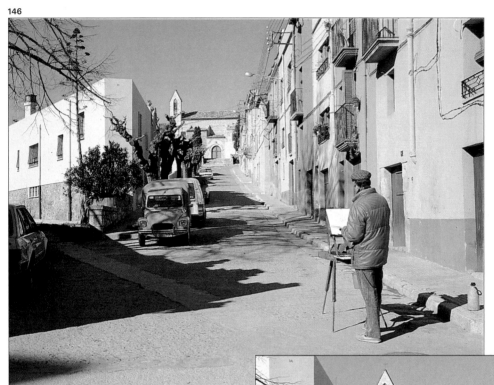

146

147

Fig. 146. In this photo‐
graph, we can see the
theme that Plana is going
to paint: The street in
perspective, with trees
and cars. Notice at what
distance from the scene
the painter puts his easel.
Now he must decide
what part of the scene
he's really going to paint;
for this he first draws a
pencil sketch.

Fig. 147. Manel Plana has
decided on the composi‐
tion you see in this pho‐
tograph. Plana explains
that he's going to ex‐
press depth through the
street's perspective, us‐
ing the verticals of trees.

Let's begin by situating ourselves with
Plana in front of a simple scene.
How does the artist relate to the theme?
We are in the street, near the sidewalk
on our right, looking at the theme. Here
is a photograph of the street in question
(fig. 146). There are two walls of houses
on each side, a church in the back‐
ground, trees on the left side of the side‐
walk, the sun shining on the walls on the
right side. In the photographs, you can
see at what distance Plana positioned
himself from the subject and what part
of it he chose (fig. 147). We could use
our two black cardboard angles to see
the same scene as the artist does. But he
does not paint exactly what we see. In‐
stead, he eliminates some elements right
from the beginning and simplifies the
shadows. In other words, he interprets
the theme.
With a very worn horsehair brush wet
with a violet Garanza—like a crimson or
red—he begins to draw on the watercolor
paper.

Plana wants to show depth, in this case,
by using parallel perspective—the theme
clearly demands it—with a vanishing
point near the point of view he has al‐
ready chosen.
The trees, he explains, help to express
this perspective, because they have ver‐
tical lines that shorten in the distance.

Try to imagine where the
parallel lines— the side‐
walk, windows, roof‐
tops—will vanish. Notice
that the horizon is at the
top of the church stairs.

Beginning with the sky

Plana explains that now it's a question of washing the entire paper with colors that will be used as a base and in many instances will remain as they are. Overall washes, big ones—only three or four—initially define the harmonies and, above all, the basic illumination.

He applies ultramarine blue softened with water for the sky (fig. 148), and on a wet area he paints two yellowish areas for clouds (fig. 149).

Next he paints the light parts of the painting—the areas illuminated by the sun (walls and floors) with a yellow-orange tone and a diluted rose-colored sienna (fig. 149). Before painting shadows, he redraws the trees, rubbing the horsehair brush almost dry (fig. 150). With the same dark color, sienna with violet-blue, more or less diluted, he paints the shadowed areas, being careful to leave out the trees.

As he paints the background color, he leaves out the trunks, making small undulating lines for the branches. Plana explains that these are undefined spaces that represent the vibrating branches without painting them one by one.

Fig. 148. Plana begins to paint the sky at the top, ''in order not to color the rest of the painting.'' Plana uses a brush and a pale violet color.

Fig. 149. He paints the areas lit by the sun with warm, pale colors, and slightly different tones in the street, the walls, and the church. He uses a thick filbert brush.

Fig. 150. He redraws the trees with an almost dry horsehair brush, rubbing it and turning it around to get a rugged texture. This leaves the outlines of the trunk undefined and only painted where he felt the need.

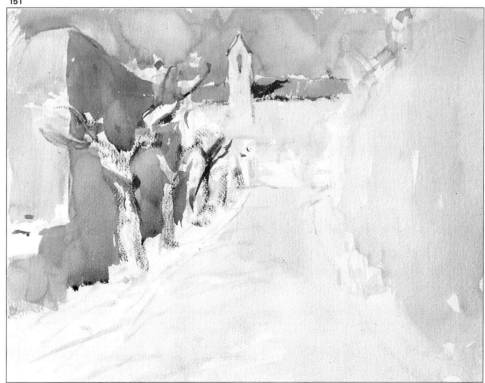

Fig. 151. These first colors, almost definitive, show where lights and darks belong above all. He paints the shadow on the left wall with a mix of sienna, blue and violet, leaving out the tree trunks.

Illumination and construction

To interpret is to eliminate, reduce, enhance, and change whatever seems superfluous.

Plana hasn't painted any cars; we deduce that in this case they don't interest him because they would hide the trees, which are becoming an important part of the painting. With a play of color ranging from pure violet to sienna, he paints the trees, illuminates the tones, and draws some branches. Without hesitating, he prepares a bluish violet for the shadows that project onto walls and trees over the street, some with great depth.

It's wonderful to watch Plana, to see how he holds the brush just so, soaking it with a lot of wet color and letting it run over the paper. He realizes that the church wall in the background will be just as light or lighter than the houses on the right. "The colors unite," he says. "This church is placed too far forward, on the same level with the house." Quickly, he masters the situation with a layer of a dull, very pale color, painting over the church wall (fig. 153).

153

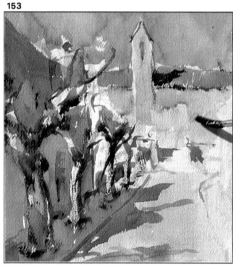

Fig. 152. With a blue-violet he paints the shadows that project onto the street, the walls, the trees, and the stairs. These are delicious shadows. It's wonderful to watch how Plana holds the brush just right. He fills the brush with wet color and paints spontaneously. He paints the shadows of the houses with depth and those of the trees more softly.

Fig. 153. Plana realizes that this background wall and the church's façade are as light as the walls of the houses on the right. The colors merge and the church doesn't hold its own, so he resolves this problem by applying a dull, pale layer.

Fig. 154. All the basics are resolved—lights and darks, depth and color. Plana has painted above the trunks with colors that range from violet to sienna, getting darker and lighter.

154

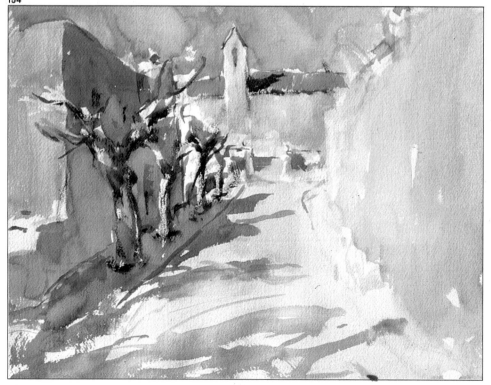

Details

Plana paints some windows with a fairly wet sienna (fig. 155), using as his guide a vanishing line on the wall on the right. He uses a warm, rather dark color for this illuminated area, making a strong contrast. Then he paints a figure and its shadow going up the street. The figure and shadow are nearly the same color, which unites them. A shading in the houses, the church door, and that's it. That's it?

It seems that Plana isn't completely satisfied. Standing in the middle of the street, he keeps looking at the sketch with his theme in the background, and he mumbles, "It's too anecdotal, too timid, too academic." He will have to paint another sketch. Plana does what we must all do when we're trying to capture a theme according to our perception and interpretation.

155

156

Fig. 155. Using almost one tone, he paints a figure and its shadow, and a door on the right side wall.

Fig. 156. He paints some shadows on the church in the background.

Fig. 157. For Plana, this painting has turned out too "academic," not "his." Nevertheless, it's done correctly.

57

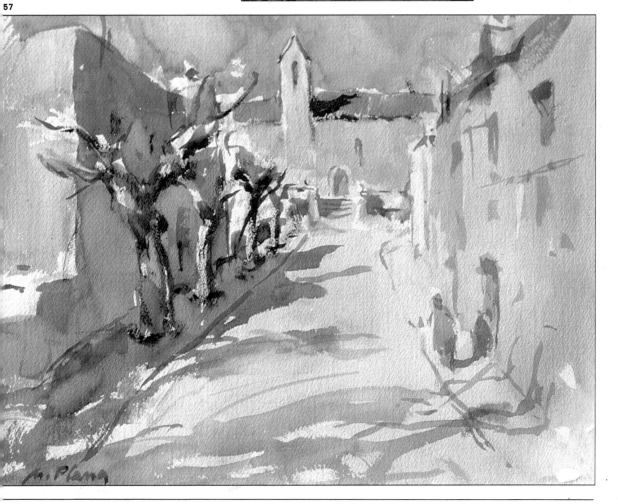

Movement and contrast

Before we realize it, Plana is already applying the wash for the sky on another piece of paper. He has drawn the theme as before, with the same composition, but with a somewhat more potent violet. He applies rounder lines by rubbing a horsehair brush over the paper, using

a great deal of force and confidence. The sense of perspective has intensified, giving the painting a certain expressionism. He paints the sky with a blue more brilliant than before and immediately uses a pure orange wash in the area above the wet blue. He paints the church in well-defined tones, darker on the roof than on the wall. This time he starts the large areas with the dark colors of the shadows, leaving out the tree trunks and branches, but not completely, since the same color appears in the interior of the trunks.

He joins the illuminated areas right from the beginning. Now he prepares his palette with plenty of water and an orange with yellow in it. He wets the brush with this color and paints all the illuminated areas, including the violet color of the drawing, which is already dry. The sketch remains visible of course, defining the outlines of the objects.

Now he waits until all of these colors dry, while he prepares a dark violet with indigo and a dash of sienna to paint the shadows projected into the street. Since the sun has gone down, the shadows now reach all the way over to the wall on the right.

He runs the shadow color over the warm violet of the trees and the wall on the left. If you look closely—you will see some white of the paper and some chaotic areas rubbed with a brush. Stand back and you will see the trees—they are

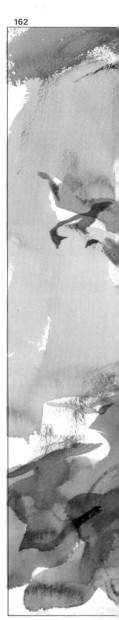

Figs. 158 to 161. In thi stronger drawing, Plan rubs blue and violet o the paper. He use orange, sienna, violet and blue so swiftly tha we can't even tak process photographs.

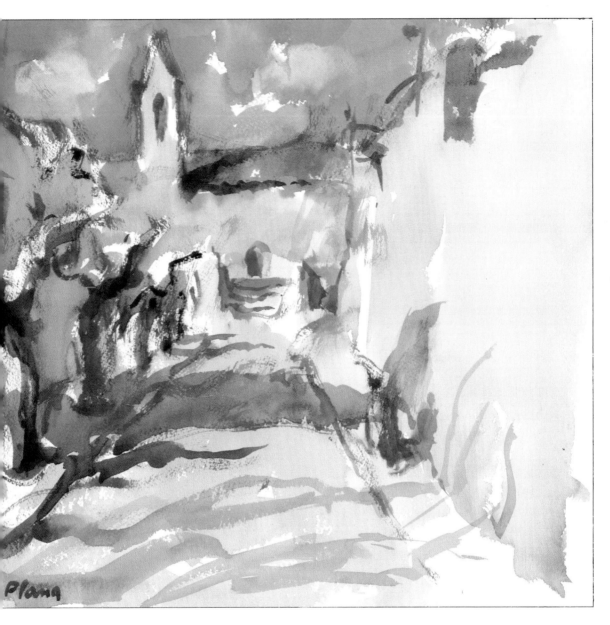

n the shadows and are constructed with great simplicity. And not only that, but the entire painting—the shadows, the trees, the sky—has a vibrant and incredible movement. This has been achieved with four washes, some white areas of the paper, and a professional knowledge of the possible ways to illuminate this street.

The artist tells me what happens in the second or third version of a theme: 'When you know the theme better, when you have drawn it and you have painted it, you know what's most important, which contrasts of light are basic, the places where you have to save the white of the paper to put it to effective use. You know what is necessary and what is superfluous, and you know better what you want to achieve. For this reason, I think today's experience is educational because it truly explains what happens to the painter in front of his subject.''

Fig. 162. This second sketch satisfies our artist more. He feels it's closer and more personal. Just by looking at it, you can see the little changes in color that transmit Plana's unique view.

Composition; drawing to illuminate

163

164

Fig. 163. This photograph was taken some hours after Plana had finished the painting. This is why the shadows are different from the painting.

165

Now that we have watched Plana work out the theme of a street in parallel perspective twice, we are ready for something a little more complex. We will see how a similar theme, a street, can be treated in many different ways.

From a plaza, we see a street with some stairs in the background leading to a cathedral (fig. 163). Plana makes a watercolor sketch to decide the framing and the composition of the theme. Most important, he constructs it with a diagonal composition, following the suggestion of the lights and darks. The interesting thing about this composition study (fig. 164) is that it simplifies the abundance of outdoor details, converting them into key areas of color, one dark and another light.

And now, as you know, it's a matter of not forgetting about the sketch.

Plana puts his paper on the drawing board, holding it in place with clips and begins to paint directly on a dry surface. He continues working in the harmony of the sketch, drawing with yellow and very light sienna, constructing the theme very briefly with a scheme of lines that serve only as references for proportions. Now changing the brush for a wider one, he begins to apply yellow, an orangy yellow, over the entire illuminated area. Later, he takes a fine-haired narrow brush and prepares a mixture of sienna and violet. He draws some motifs in the houses over a wet surface. All of a sudden Plana remembers his sketch. He returns to dampen the thick brush in order to color the shadowed area with sienna, using large brushstrokes.

Fig. 164. In five minutes, Plana has painted the essence of the theme. He uses yellow and burnt sienna, dividing the paper in two parts.

Fig. 165. First he draws with a very pale yellow, and, with a wider brush, he applies yellow and orangish colors.

166

Fig. 166. He continues with pure dark cadmium yellow in order to paint a color more in shadow. He uses the horsehair brush loaded with sienna and violet to strengthen some parts of the drawing.

He also paints on the wet surface of the houses, where the darks of the rooftops and balconies correspond to each other; the shades of sienna vary slightly. Then he paints over the yellow background to suggest the shadows in the steps. The shadows of the houses and the darker horizontal brushstrokes correspond to the intense darkness of each step.

Fig. 168. He uses a fine narrow brush with a minimum of sienna and violet to draw some motifs of the houses on a wet surface.

168

Fig. 167. Using a thick brush with sienna, Plana colors the shadowed area with big brushstrokes. He paints on a wet surface the darks of the rooftops and balconies, slightly varying the shades of this sienna color—more red here, more tan there.

167

169

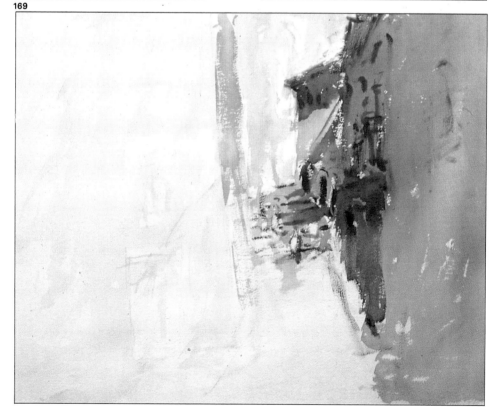

Fig. 169. Plana uses four colors for the shadows of the steps. He solves the problem of the shadows on the right. He has painted mainly on the right side of the paper so far, while the left remains intact. When you work in watercolor, sometimes it is convenient to take advantage of the dampness to finish some part.

Layering, scratching, shading

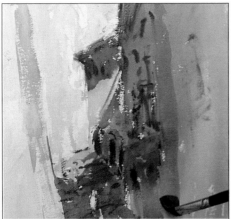

170

171

Plana has decided to focus on this area because the shadows seem lost, and he wants to reinforce them. He continues with a dark color, somewhat more violet this time, painting over the first color of the houses' shadows. Then he uses the same color, but less watery for nearly the entire street, letting only a few figures and a part of the stairs in the background remain free—the only area that he gives full sun.

Plana always lets the colors speak for themselves, expressing all their beauty, not forcing precise definitions of a window, the eaves, the cornice, and so on. Plana works on the left side of the paper: He paints a sienna layer over the yellow.

Fig. 170. Plana returns to the shaded area on the right, going over the details that don't affect the overall look of the painting. He uses a purplish color.

Fig. 171. He intensifies the tone of the background wall, keeping the previous color only in the large window. Now it becomes a bright wall.

Fig. 172. On a wet surface, he draws the bars of a balcony, scratching off the paint to expose the white of the paper.

172

173

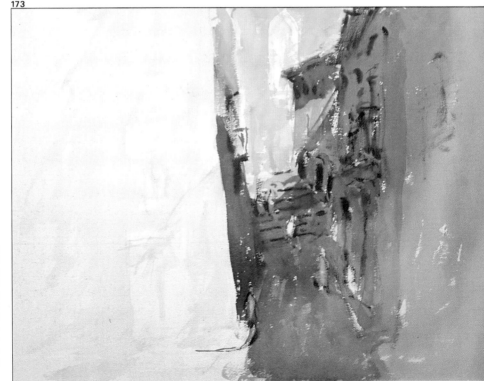

Fig. 173. Plana dilutes pure sienna, an earth red, for the wall's shadow on the left. It is almost as if the color has been rubbed. Now Plana shows the entrance of the street. He has painted in dark colors, allowing light in only a few points and a part of the stairs.

The danger of the actual

With a fine brush, he marks the line to represent the gothic arch of the large window in the background. With wide brushstrokes of intense sienna, he works out the triangular shadow on the left side of the street. But now he realizes that the model has made him forget his inten-

tions. Plana says, "I have painted this large window with so much detail that it's too intimate. It's not integrated with the background."

Plana says that he got carried away with what he saw, and he forgot the overall painting. Pay attention when you paint!

Fig. 174. Plana now paints the wall facing us with a watery color, leaving out some squares for the windows.

Fig. 175. He selects a fine brush to draw the edge and the shadows of the large window in the background with violet.

Fig. 176. Finally he paints with some sienna, finishing the painting's composition exactly as he had designed it in the first sketch.

74

175

176

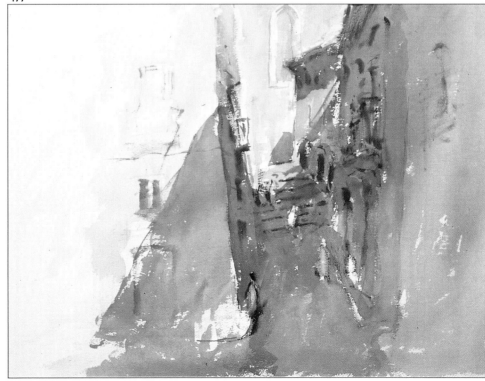

177

Fig. 177. Plana insists on interpreting what he sees. On occasion, we fall into a trap; we paint what we see without relating it to the rest of the painting. That's what happened to Plana with the large window in the background.

The last stage

The evolution of this painting has been a thorough workout in the art of painting an urban landscape watercolor.
In truth this scene is not very complicated, considering that it's a street with lights and darks, with clear contrast. This makes use aware that, even with an apparently simple theme, we have to be alert to what's happening on the paper. We must be aware of even more than what we're looking at, because what we're looking at can confuse us.

curb, and adds a few figures with colors he's already used. Everything is in its place for a clear and effective composition, sustained by a good illumination of the darks and lights—everything except, the large window in the background.

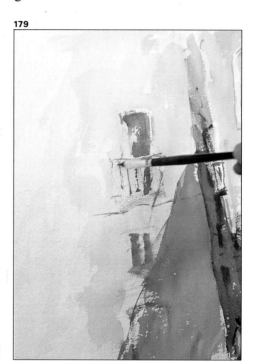

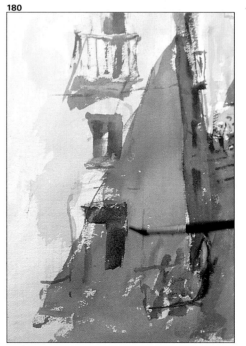

Plana now paints some elements on the front wall on the left. The details have to be constructed on this wall because it's close to the painter. Here there is no diffusion in the distance. This is why he paints carefully, layer by layer, waiting for each to dry, cleaning his brush and preparing a darker color. He paints the balcony bars, rubbing the brush so as not to create too much hard contrasts. Then he prepares a darker, slightly bluish color to put different shades in the shadows. He darkens the shadows in the street-level door as it corresponds with the area of the wall already in the shade. He draws a line to represent the sidewalk

Figs. 178 to 180. Plan finishes by resolving th left side of the paintin drawing windows ar doors, defining th shadows with light ar dark tans, and paintir over the previous tone He puts in a few figure using a narrow brush.

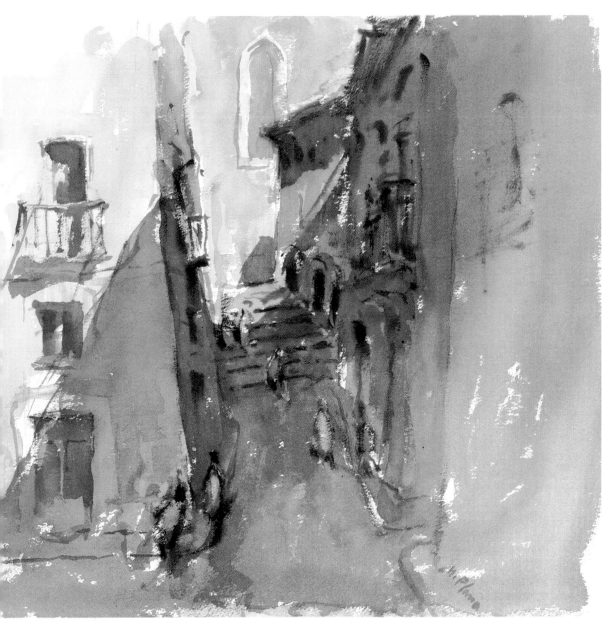

Fig. 181. Plana has been increasing the layers of color in the painting little by little, often working on a dry surface. In some areas, especially on the buildings, he works on a wet surface.

We notice how Plana uses the watercolor in the traditional way, on a dry surface, not wetting the paper. But in some areas, where he doesn't want defined outlines in the middle of a shadow, he paints on a wet surface. Also notice the color harmonies, always subtle and elegant and natural. Many colors appear more or less dull by virtue of the complementary relation of yellow and violet.

The panorama: Measuring

wetting it continuously with ultramarine blue and cadmium orange, allowing the colors to blend. But he works carefully, leaving out the area that corresponds to the mountains. Then, without waiting for the sky area to dry, he wets the horse-hair brush with violet and outlines the mountain. He does this on a wet surface to make the outline very diffuse, to imply distance.

It is the month of January, a sunny day like any other, after lunch. But we don't have much time to paint; the afternoon is short and the light is going quickly, turning orange, then rosy, as time passes. This changing light can be seen in the photograph in figure 182.

Plana gets ready to paint from the upper part of a street, looking down. The theme is more or less what is in the photograph. It is a view that includes a wide panorama of the town, with the mountains in the background, bare trees on the street, a part of an old wall that long ago surrounded the city, and the bell tower of a church. Plana asks me to point out that this street is the same one that he painted in those first sketches (pages 88 to 93), but looking in another direction. "Really," he says, "you don't have to move much to come up with different themes. Sometimes all you have to do is turn the easel." Plana draws directly with a horsehair brush, using a violet color. He draws taking measurements, correcting the proportions of large areas— a space for the sky, another for the mountains and for the houses on both sides of the street. Sometimes he stops his brush on one point while looking at his theme. Then he observes relationships and continues. After drawing for a brief amount of time, he begins applying color to the sky, as always on a dry surface. He uses a wide brush,

Fig. 182. Here is a photograph of the theme Plana is going to paint in watercolor on Whatman paper. It's an afternoon in the middle of winter. The trees don't have any leaves; the sun sets early; the light is warm.

Figs. 183 to 186. Please follow the painting process described in the text.

Now he paints the mountains simply, using orange for the illuminated area and violet for the dark. Once again he allows both colors to blend, but he also rubs the brush to reveal some whites to suggest light on the open mountain shapes. He works with orange until he reaches the borders corresponding to the town. With a brush, he draws the exact edges of the houses. He scratches the wet surface to mark a chimney or some light-colored vertical line above the orangish stain in the background.

Figs. 187 and 188. Plana begins at the uppermost part and travels downward, painting the area of the sky and the hills with contrasting colors— oranges and reds against violets and blues. He leaves blank the area where the town will be.

187

188

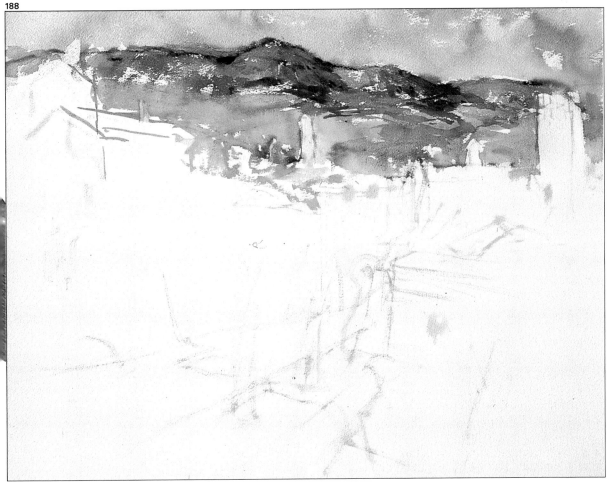

Drawing-painting

Plana colors a whole area on a dry surface with the same orange applied in the previous stage, using the color a little bit wetter and lighter than before—preparing the whole town in a single block. Later he will build up each element. He reserves some whites for the tree trunks.

Before the painting has finished drying, he colors some dark areas with a dark sienna—the watchtower on the wall, for example—and immediately uses his fingernail to scratch in the shapes of the branches of a tree. Now, with pure violet, he paints over this sienna color and leaves out the branch of a tree. Almost by chance, he solves the problem of the shadows that comprise the buildings in the background, with four little brush-strokes.

At this moment, the sun goes down and the light vanishes. Plana will have to finish tomorrow.

189

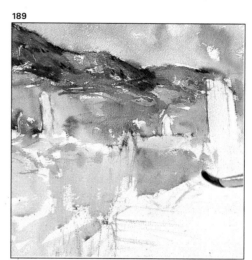

Fig. 189. The first thing Plana does is use an orangy wash over the entire area. He immediately intensifies this color in areas strongly lit by the sun.

Fig. 190. Next he uses Van Dyck red and pure sienna for some shadows that indicate rooftops and walls.

Fig. 191. Then, over a wet sienna, he scratches with his nail and draws branches.

Fig. 192. Plana draws the houses at the same time that he paints the area in the shade. He separates light from dark with color, and the theme is constructed.

Fig. 193. He continues drawing and painting at the same time. The trees' definition is complete; from it we get the violet shadow in the background, which has white areas. He uses a sienna with violet for some areas of the trunk and a sienna with indigo to draw the branches and some dark areas, as well as the white of the paper.

190

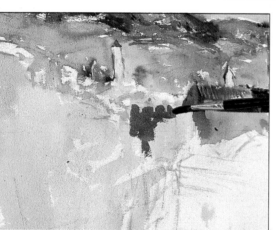

191

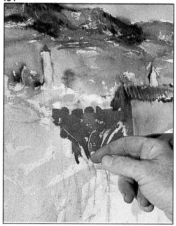

192

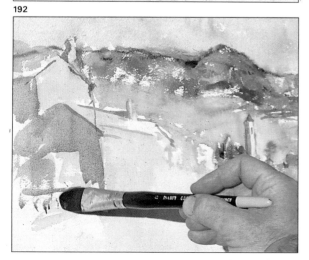

193

ig. 194. He continues drawing with color; when he paints the shadows, the building akes shape.

ig. 195. This watercolor as turned out to be very nteresting. Notice how Plana has continued downward into the foreground, each time "squeezing" more contrast out. In the buildings n the background, the shadows are soft and blue, while in the foreground the buildings have their own color and are darker only in certain areas.

Notice how the colors appear much warmer and darker than they did in the last photographs. If you compare them with the next photo, taken in the early afternoon of the following day, you will see a difference.

The next day we are in the same place at the same time. Plana continues the

194

process of drawing and constructing while he paints. The magic of dark and light is revealed in careful placement of the shadows. Suddenly all the known elements appear, but without details.

In this way, Plana definitively constructs the trees with two colors, the white of the paper, and a fingernail for scraping. And, with a color, letting what's underneath show, he draws the building on the right side of the painting. He does this quickly in order to paint the shadows projected into the street by this building and the trees. He has measured the relative size of each shadow, noted its exact placement and color. It is lighter, paler, in the background and more contrasted and dark in the foreground. Suddenly, everything is in its place, with the correct distances. A sense of depth appears.

195

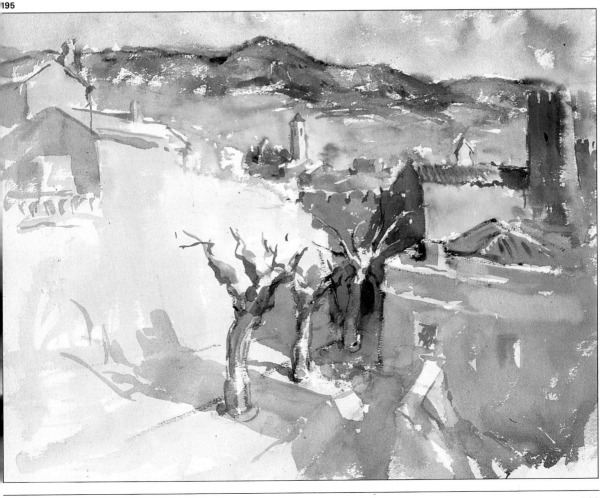

Glorious warm colors

The reddish overtones of the late afternoon light start to become evident; sunset is looming. But this time Plana is almost finished so we have no problems. While the color in the progress photographs must already have changed, it doesn't matter, because you are familiar with the harmonies Plana has used by now. You know how he has taken advantage of the painting on a dry surface, on a wet surface in the background, and in some places in the town. You are aware of how he has solved the construction problems of the theme, first painting the light tones. You know how his shapes are based on proper illumination with bright contrast and intermediate grays.

Plana now begins the process of adjusting and dampening some areas where the color is too dark, for example in the little tower (fig. 198). He adds layers in some places—the windows of this first

Indeed, now that we are talking about the question of darks and lights, Plana observes—something I haven't realized—that the darks of the mountains are different from those of the houses. He says, "There's a mistake. The shadow on the mountains reflects the early afternoon light, when I began this painting, and the shadows between the houses

196

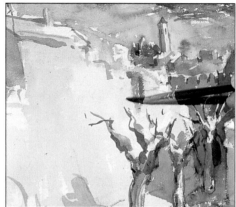

197

198

199

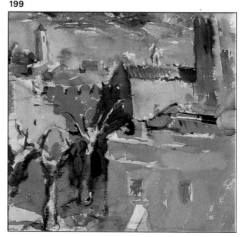

200

building on the right— and touches up some darks in the street and on the wall of the houses on the left. At the same time, he wets the brush with a more orangy color and paints the windows of these houses with delicate layers.

He adds some reds and oranges in the background, accentuating even more the colors belonging to this hour of the day. Plana explains that in some way he is "lighting up" with warm colors. Even the darks have a tendency to be warm here, although they seem somewhat cooler than the other colors.

Figs. 196 to 199. In these last moments of this session, taking advantage of the sun's rays, which are already very slanted and red, Plana paints some details, adjusts some tones, and redefines some shapes, separating them from the background.

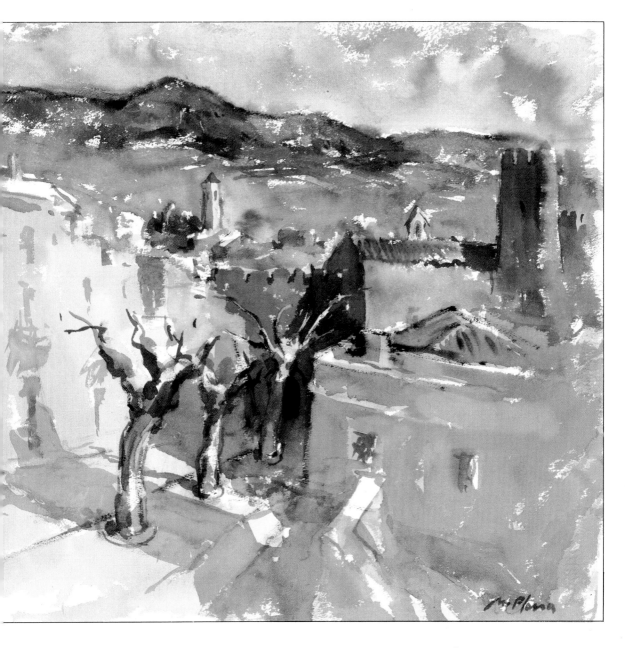

are darker because I painted them later. I want to point this out, although it's hardly even noticeable. In this case, I don't give it any more importance because the painting was more about con-structing shapes, mountains as well as buildings. I want to mention it because it brings up the same problem I had before: If we look too much at the theme, we don't see the painting.''

Fig. 200. This watercolor was done in two work sessions. It's complete in composition, superim-posing different dimen-sions. Plana united the theme with a warm range of many shades.

Painting in the studio

Today, Plana is going to paint in his studio, beginning with some sketches that he made from an elevated point of view in the big city.

He starts by measuring and drawing the big areas. He emphasizes the areas that are going to be dark, and paints the entire paper with a very watery sienna wash, reserving whites almost by chance. He paints a triangle in the upper part of the building similar to a wall, and afterwards, outlines the more complicated forms within.

Figs. 201 to 203. The two sketches are Plana's basis for painting his theme. Below is the first stage of the painting, which he drew with a horsehair brush, using a yellowish sienna.

201

202

203

The lightest and the darkest

Plana continues with an orangy color, painting dark over light in the painting's central point of interest: The building in the foreground, a well-known city bar. Next, painting over a wet surface, he adds ultramarine blue—just a little—and violet, to bring out subtle shades in the old walls.

Now he paints above the horizon, above the bar's roof, with violets and siennas, making the shape of the building stand out.

He prepares a color made up basically of sienna, with a little violet and indigo. In it he wets the thickest brush, soaking it thoroughly, and, using almost undiluted color, paints the shadow on the building of the bar directly over the light. This is an enormous and powerful shadow, which leads down to the sidewalk and onto the street.

Fig. 204. The second step consists of painting the dark areas in such a way that the picture is divided in two parts. Plana continually shades or tints the colors, he doesn't paint them equally everywhere; he also lets the underneath colors show.

Fig. 205. The second stage of watercolor shows us the two main colors. Plana uses siennas and blues above the building, to make it stand out from the background, to separate the foreground and background.

Adjusting the most important shades

Here Plana prepares the palette with a greenish orange, yellow, red, and green. With this color mixture, he paints over the building, really bringing it to life. He quickly dulls this color by adding violet to eliminate some of the brightness. Next he paints the windows and the shaded archways, scraping his fingernail where it's necessary to add light.

Now he adjusts the shaded areas of the theme: The shadow projecting from the building on the right, cooler and grayer than the one in the foreground. The reserved white areas suggest the almost transparent bulk of the leafless branches. Then, with indigo and a little very intense turquoise blue, he paints underneath the brightly lit awning, reserving little white circles for the bar tables.

206

Fig. 206. Plana continues to paint all the dark areas of the theme. He began with the ones with more depth, under the awning. In fact, we see the awning by way of this dark area. He continues with the shadow that the building projects onto the right side of the street.

Fig. 207. Notice in this third stage that the shadows are not all the same. Plana has differentiated them so that they don't merge visually. Notice also that the trees appear in the negative as do the bar tables. Plana has reinforced the color of the façade creating two different planes: the awning and the wall.

207

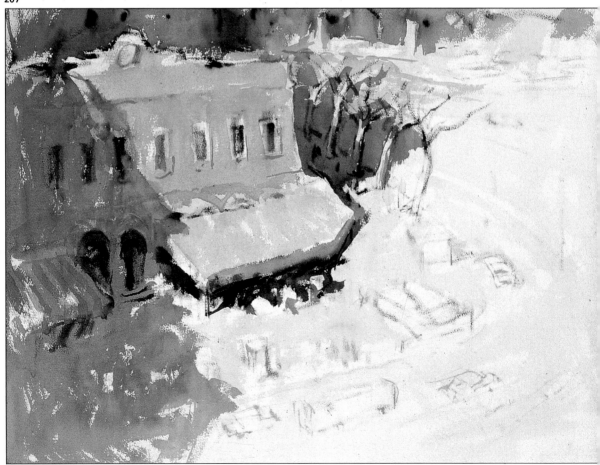

The painting comes to life

With a dull color, Plana draws and paints the striped awning, and keeps painting soft layers on the building façade. For now, each area, each shadow, is illuminated and has a distinct color; each one begins to situate itself where it belongs.

Next he prepares a color with a cool, absolutely dull quality, a very pale gray green—with a great deal of water—and paints it over the sidewalk, which has been pale yellow until now. The building and the awning will light up even more, as will the reserved areas on the sidewalk.

And now, like a magician, he brings the painting to life. With a fine brush, he begins to draw in indigo: the stairs, the railings, and the figures.

Fig. 208. Plana now paints the sidewalk with a dull color, a pale gray, reserving spaces for a variety of objects.

Fig. 209. With pale gray, Plana has increased the brightness of the awning and the façade at the same time, making things appear on the sidewalks. These things are expressed simply by leaving out areas and darkening areas for cast shadows.

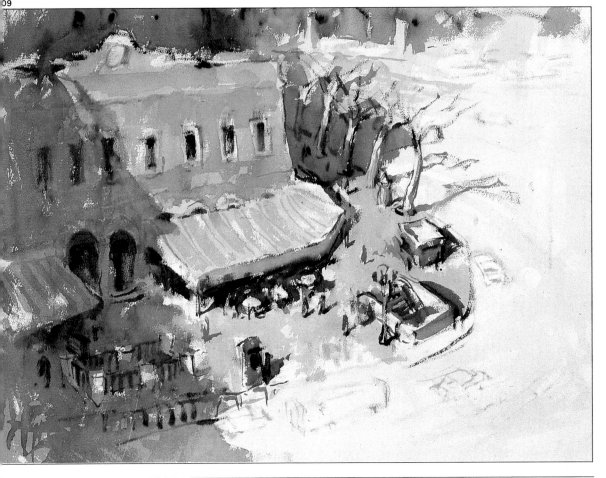

Harmony in the grayed colors

Squirrel-hair brushes in a cat's-tongue shape give soft, rounded effects, which Plana uses here to make "urban furniture" (kiosks, poster columns, steps). Use this system: first, paint the shaded area of a particular object, leaving out the light area. Then shade and add detail to both areas. And third, paint the shadows the object projects onto the floor and the wall.

Plana is going to do the whole right side of the painting, the street and the horizon. He does it simply, with a fine brush and a pale blue-violet color, drawing and painting the shadows. And as he paints, objects begin to take form from abstract brushstrokes, as, for example, the fine horizontal lines that become steps.

He works on a wet surface when he doesn't want sharp outlines—for example, for the cars that are further away and in motion.

Next he paints the cars that are closer and the bus, using the dark-areas-first method described above.

Letting the shadows merge with the background, Plana creates a sensation of diffuse movement.

210

Fig. 210. Plana draw some details, like th guard rail, with a horse hair brush.

Fig. 211. He paints th cars with orange an almost-black over a we surface.

214

211

212

Fig. 212. He then uses a dry brush to absorb color and blur the outlines somewhat, taking advantage of the absorbed color to paint the shadow; the same way he did with the bus.

213

Fig. 213. After painting a layer of color for the street, leaving out the whites for the crosswalk, he paints abstract areas on the sidewalk that, when we look at them in the total picture, become human figures.

Finally, covering white areas that disturb him, Plana adds a few more figures (and their shadows).

With this magnificent watercolor we conclude these lessons on painting urban landscapes in watercolor.

Now it is the moment to start painting, you, by yourself, remembering that you can always refer to this book when you need ideas, resources, or solutions to problems. We hope it has been useful to you.

Fig. 214. The shapes in the background on the right have been resolved with simplicity. Horizontal stripes are steps; little vertical brushstrokes are the openings between a stone railing. The cars almost disappear and melt into the environment.

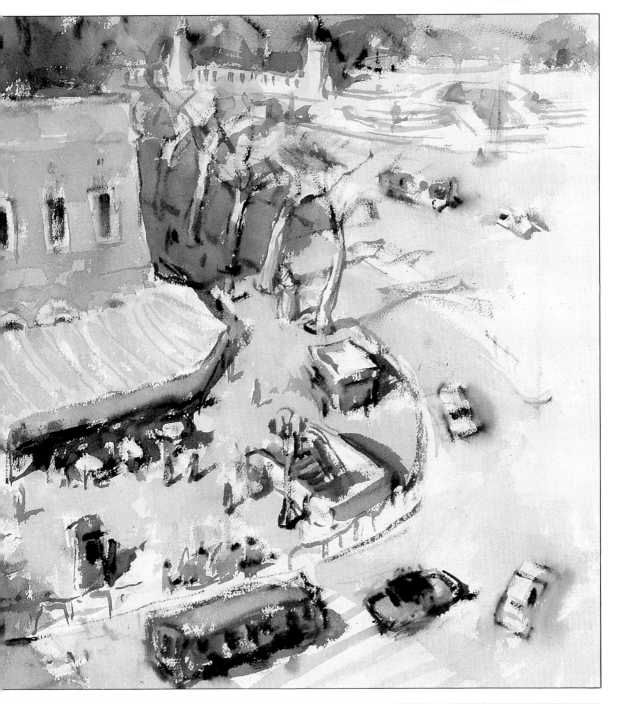